# MEMORIES OF A
# PRE-RAPHAELITE
# YOUTH

*Ford Madox Ford*

# MEMORIES OF A PRE-RAPHAELITE YOUTH

*Selections from the memoirs and autobiographical writings*

PALLAS ATHENE

*These selections were parts of a larger anthology of the memoirs of Ford Madox Ford (1873-1939) published in 1971 with the title* Your Mirror to My Times, The Selected Autobiographies and Impressions of Ford Madox Ford, *edited by Michael Killigrew.*

*They are extracted from* Ancient Lights, *published 1911;* Return to Yesterday, *published 1932; and* Mightier than the Sword, *1938. The frequent ellipses are Ford's own.*

*This selection published 2012 (reprinted 2018) by Pallas Athene (Publishers) Ltd, Studio 11A Archway Studios, 25-27 Bickerton Road London N19 5JT*

*www.pallasathene.co.uk*

 pallasathenebooks

 Pallas_books

 PallasAtheneBooks

 Pallasathene0

ISBN *978-1-84368-085-7*

*Cover: Ford Madox Ford sitting to his grandfather Ford Madox Brown for his portrait as William Tell's Son (c. 1877). After the caricature by J. Hipkins, National Library of Scotland. The painting is in the Fitzwilliam Museum, Cambridge*

*Printed in England*

# CONTENTS

To all who have taken in hand
'the sweetening of the world . . .
the making it safe for children.'

# A PRE-RAPHAELITE YOUTH

## THE WRITER TO HIS CHILDREN

I MADE for myself the somewhat singular discovery that I can only be said to have grown up a very short time ago—perhaps three months, perhaps six. I discovered that I had grown up only when I discovered quite suddenly that I was forgetting my own childhood. My own childhood was a thing so vivid that it certainly influenced me, that it certainly rendered me timid, incapable of self-assertion and, as it were, perpetually conscious of original sin, until only just the other day. For you ought to consider that upon the one hand as a child I was very severely disciplined, and, when I was not being severely disciplined, I moved among somewhat distinguished people who all appeared to me to be morally and physically twenty-five feet high. The earliest thing that I can remember is this, and the odd thing is that, as I remember it, I seem to be looking at myself from outside. I see myself a very tiny child in a long, blue pinafore, looking into the breeding-box of some Barbary ring-doves that my grandmother kept in the window of the huge studio in Fitzroy Square. The window itself appears to me to be as high as a house, and I myself to be as small as a door-step, so that I stand on tiptoe and just manage to get my eyes and nose over the edge of the box, while my long curls fall forward and tickle my nose. And then I perceive greyish and almost shapeless objects with, upon them, little speckles like the very short spines of hedge-hogs, and I stand with the first surprise of my life and with the first wonder of my

life. I ask myself, can these be doves—these unrecognisable, panting morsels of flesh? And then, very soon, my grandmother comes in and is angry. She tells me that if the mother dove is disturbed she will eat her young. This, I believe, is quite incorrect. Nevertheless, I know quite well that for many days afterwards I thought I had destroyed life, and that I was exceedingly sinful. I never knew my grandmother to be angry again, except once, when she thought I had broken a comb which I had certainly not broken. I never knew her raise her voice; I hardly know how she can have expressed anger; she was by so far the most equable and gentle person I have ever known that she seemed to me to be almost not a personality but just a natural thing. Yet it was my misfortune to have from this gentle personality my first conviction—and this, my first conscious conviction, was one of great sin, of a deep criminality. Similarly with my father, who was a man of great rectitude and with strong ideals of discipline. Yet for a man of his date he must have been quite mild in his treatment of his children. In his bringing-up, such was the attitude of parents toward children that it was the duty of himself and his brothers and sisters at the end of each meal to kneel down and kiss the hands of their father and mother as a token of thanks for the nourishment received. So that he was, after his lights, a mild and reasonable man to his children. Nevertheless, what I remember of him most was that he called me 'the patient but extremely stupid donkey.' And so I went through life until just the other day with the conviction of extreme sinfulness and of extreme stupidity.

For such persons the world of twenty-five years ago was rather a dismal place.* You see there were in those days a number of those terrible and forbidding things—the Victorian great figures. To me life was simply not worth living because of the existence of Carlyle, of Mr Ruskin, of Mr Holman Hunt, of Mr Browning or of the gentleman

* Written in 1910.

who built the Crystal Palace. These people were perpetually held up to me as standing upon unattainable heights, and at the same time I was perpetually being told that if I could not attain these heights I might just as well not cumber the earth. What then was left for me? Nothing. Simply nothing.

Now, my dear children—and I speak not only to you, but to all who have never grown up—never let yourselves be disheartened or saddened by such thoughts. Do not, that is to say, desire to be Ruskins or Carlyles. Do not desire to be great figures. It will crush in you all ambition; it will render you timid, it will foil nearly all your efforts. Now-a-days we have no great figures, and I thank Heaven for it, because you and I can breathe freely. With the passing the other day of Tolstoy, with the death just a few weeks before of Mr Holman Hunt, they all went away to Olympus, where very fittingly they may dwell. And so you are freed from these burdens which so heavily and for so long hung upon the shoulders of one—and of how many others? For the heart of another is a dark forest, and I do not know how many thousands other of my fellowmen and women have been so oppressed. Perhaps I was exceptionally morbid, perhaps my ideals were exceptionally high. For high ideals were always being held before me. My grandfather, as you will read, was not only perpetually giving; he was perpetually enjoining upon all others the necessity of giving never-endingly. We were to give not only all our goods, but all our thoughts, all our endeavours; we were to stand aside always to give openings for others. I do not know that I would ask you to look upon life otherwise or to adopt another standard of conduct; but still it is as well to know beforehand that such a rule of life will expose you to innumerable miseries, to efforts almost superhuman, and to innumerable betrayals—or to transactions in which you will consider yourself to have been betrayed. I do not know that I would wish you to be spared any of these unhappinesses. For the past generosities of one's life are the only milestones on

that road that one can regret leaving behind. Nothing else matters very much, since they alone are one's achievement. And remember this, that when you are in any doubt, standing between what may appear right and what may appear wrong, though you cannot tell which is wrong and which is right, and may well dread the issue— act then upon the lines of your generous emotions, even though your generous emotions may at the time appear likely to lead you to disaster. So you may have a life full of regrets, which are fitting things for a man to have behind him, but so you will have with you no causes for remorse. So at least lived your ancestors and their friends, and, as I knew them, as they impressed themselves upon me, I do not think that one needed, or that one needs to-day, better men. They had their passions, their extravagances, their imprudences, their follies. They were sometimes unjust, violent, unthinking. But they were never cold, they were never mean. They went to shipwreck with high spirits. I could ask for nothing better for you if I were inclined to trouble Providence with petitions.

## THE NATURE OF THE BEAST

Just a word to make plain the actual nature of this book: it consists of impressions. When some parts of it appeared in serial form, a distinguished critic fell foul of one of the stories that I told. My impression was and remains that I heard Thomas Carlyle tell how at Weimar he borrowed an apron from a waiter and served tea to Goethe and Schiller, who were sitting in eighteenth-century court-dress beneath a tree. The distinguished critic of a distinguished paper commented upon this story, saying that Carlyle never was in Weimar, and that Schiller died when Carlyle was aged five. I did not write to this distinguished critic, because I do not like writing to the papers, but I did write to a third party. I said that a few days before

that date I had been talking to a Hessian peasant, a veteran of the war of 1870. He had fought at Sedan, at Gravelotte, before Paris, and had been one of the troops that marched under the Arc de Triomphe. In 1910 I asked this veteran of 1870 what the war had been all about. He said that the Emperor of Germany, having heard that the Emperor Napoleon had invaded England and taken his mother-in-law, Queen Victoria, prisoner—that the Emperor of Germany had marched into France to rescue his distinguished connection. In my letter to my critic's friend I said that if I had related this anecdote I should not have considered it as a contribution to history, but as material illustrating the state of mind of a Hessian peasant. So with my anecdote about Carlyle. It was intended to show the state of mind of a child of seven brought into contact with a Victorian great figure. When I wrote the anecdote I was perfectly aware that Carlyle never was in Weimar while Schiller was alive, or that Schiller and Goethe would not be likely to drink tea, and that they would not have worn eighteenth-century court-dress at any time when Carlyle was alive. But as a boy I had that pretty and romantic impression, and so I presented it to the world—for what it was worth. So much I communicated to the distinguished critic in question. He was kind enough to reply to my friend, the third party, that, whatever I might say, he was right and I was wrong. Carlyle was only five when Schiller died, and so on. He proceeded to comment upon my anecdote of the Hessian peasant to this effect: at the time of the Franco-Prussian War there was no Emperor of Germany; the Emperor Napoleon never invaded England; he never took Victoria prisoner, and so on. He omitted to mention that there never was and never will be a modern Emperor of Germany.

I suppose that this gentleman was doing what is called 'pulling my leg,' for it is impossible to imagine that any one, even an English literary critic or a German professor or a mixture of the two, could be so wanting in a sense of

humour—or in any sense at all. But there the matter is, and this book is a book of impressions.

## MY GRANDFATHER AND HIS CIRCLE

Says Thackeray:

'On his way to the city, Mr Newcome rode to look at the new house, No. 120 Fitzroy Square, which his brother, the Colonel, had taken in conjunction with that Indian friend of his, Mr Binnie.... The house is vast but, it must be owned, melancholy. Not long since it was a ladies' school, in an unprosperous condition. The scar left by Madame Latour's brass plate may still be seen on the tall black door, cheerfully ornamented, in the style of the end of the last century, with a funeral urn in the centre of the entry, and garlands and the skulls of rams at each corner.... The kitchens were gloomy. The stables were gloomy. Great black passages; cracked conservatory; dilapidated bath-room, with melancholy waters moaning and fizzing from the cistern; the great large blank stone staircase—were all so many melancholy features in the general countenance of the house; but the Colonel thought it perfectly cheerful and pleasant, and furnished it in his rough-and-ready way.'—*The Newcomes.*

And it was in this house of Colonel Newcome's that my eyes first opened, if not to the light of day, at least to any visual impression that has not since been effaced. I can remember vividly, as a very small boy, shuddering, as I stood upon the door-step, at the thought that the great stone urn, lichened, soot-stained and decorated with a great ram's head by way of handle, elevated only by what looked like a square piece of stone of about the size and shape of a folio-book, might fall upon me and crush me entirely out of existence. Such a possible happening, I remember, was a frequent subject of discussion among Madox Brown's friends.

Ford Madox Brown, the painter of the pictures called 'Work' and 'The Last of England,' and the first painter in England, if not in the world, to attempt to render light exactly as it appeared to him, was at that time at the height of his powers, of his reputation and of such prosperity as he enjoyed. His income from his pictures was considerable, and since he was an excellent talker, an admirable host and, indeed, unreasonably open-handed, the great, formal and rather gloomy house had become a meeting-place for almost all the intellectually unconventional of that time. Between 1870 and 1880 the real Pre-Raphaelite movement was long since at an end; the Aesthetic movement, which also was nicknamed Pre-Raphaelite, was, however, coming into prominence, and at the very heart of this movement was Madox Brown. As I remember him, with a square white beard, with a ruddy complexion and with thick white hair parted in the middle and falling to above the tops of his ears, Madox Brown exactly resembled the king of hearts in a pack of cards. In passion and in emotions—more particularly during one of his fits of gout—he was a hard-swearing, old-fashioned Tory; his reasoning, however, and circumstances made him a revolutionary of the romantic type. I am not sure, even, that towards his latter years he would not have called himself an Anarchist, and have damned your eyes if you had faintly doubted this obviously extravagant assertion. But he loved the picturesque, as nearly all his friends loved it. About the inner circle of those who fathered and sponsored the Aesthetic movement there was absolutely nothing of the languishing. They were to a man rather burly, passionate creatures, extraordinarily enthusiastic, extraordinarily romantic and most impressively quarrelsome. Neither about Rossetti nor about Burne-Jones, neither about William Morris nor P. P. Marshall—and these were the principal upholders of the firm of Morris & Company, which gave aestheticism to the western world—was there any inclination to live upon the smell of the lily. It was the outer ring, the

disciples, who developed this laudable ambition for poetic pallor, for clinging garments and for ascetic countenances. And it was, I believe, Mr Oscar Wilde who first formulated this poetically vegetarian theory of life in Madox Brown's studio at Fitzroy Square. No, there was little of the smell of the lily about the leaders of this movement. Thus it was one of Madox Brown's most pleasing anecdotes—at any rate, it was one that he related with the utmost gusto—how William Morris came out onto the landing in the house of the 'Firm' in Red Lion Square and roared downstairs:

'Mary, those six eggs were bad. I've eaten them, but don't let it occur again.'

Morris, also, was in the habit of lunching daily off roast beef and plum-pudding, no matter at what season of the year, and he liked his puddings large. So that, similarly, upon the landing one day he shouted:

'Mary, do you call that a pudding?'

He was holding upon the end of a fork a plum-pudding about the size of an ordinary breakfast-cup, and having added some appropriate objurgations, he hurled the edible downstairs onto Red-Lion Mary's forehead. This anecdote should not be taken to evidence settled brutality on the part of the poet-craftsman. Red-Lion Mary was one of the loyalest supporters of the 'Firm' to the end of her days. No, it was just in the full-blooded note of the circle. They liked to swear, and, what is more, they liked to hear each other swear. Thus another of Madox Brown's anecdotes went to show how he kept Morris sitting monumentally still, under the pretence that he was drawing his portrait, while Mr Arthur Hughes tied his long hair into knots for the purpose of enjoying the explosion that was sure to come when the released Topsy—Morris was always Topsy to his friends—ran his hands through his hair. This anecdote always seemed to me to make considerable calls upon one's faith. Nevertheless, it was one that Madox Brown used most frequently to relate, so that no doubt something of the sort must have occurred.

No, the note of these aesthetes was in no sense ascetic. What they wanted in life was room to expand and to be at ease. Thus I remember, in a sort of golden vision, Rossetti lying upon a sofa in the back studio with lighted candles at his feet and lighted candles at his head, while two extremely beautiful ladies dropped grapes into his mouth. But Rossetti did this not because he desired to present the beholder with a beautiful vision, but because he liked lying on sofas, he liked grapes and he particularly liked beautiful ladies. They desired, in fact, all of them, room to expand. And when they could not expand in any other directions they expanded enormously into their letters. And—I don't know why—they mostly addressed their letters abusing each other to Madox Brown. There would come one short, sharp note, and then answers occupying reams of note-paper. Thus one great painter would write:

'Dear Brown—Tell Gabriel that if he takes my model Fanny up the river on Sunday I will never speak to him again.'

Gabriel would take the model Fanny up the river on Sunday, and a triangular duel of portentous letters would ensue.

Or again, Swinburne would write:

'Dear Brown—If P. says that I said that Gabriel was in the habit of——, P. lies.'

The accusation against Rossetti being a Gargantuan impossibility which Swinburne, surely the most loyal of friends, could impossibly have made, there ensued a Gargantuan correspondence. Brown writes to P. how, when and why the accusation was made; he explains how he went round to Jones, who had nothing to do with the matter, and found that Jones had eaten practically nothing for the last fortnight, and how between them they had decided that the best thing that they could do would be to go and tell Rossetti all about it and of how Rossetti had had a painful interview with Swinburne, and how unhappy everybody was. P. replies to Brown that he had never uttered any such words upon any such occasion; that

upon the occasion he was not present, having gone round to Ruskin, who had the toothache, and who read him the first hundred and twenty pages of *Stones of Venice*; that he could not possibly have said anything of the sort about Gabriel, since he knew nothing whatever of Gabriel's daily habits, having refused to speak to him for the last nine months because of Gabriel's intolerable habit of back-biting, which he was sure would lead them all to destruction, and so deemed it prudent not to go near him. Gabriel himself then enters the fray, saying that he has discovered that it is not P. at all who made the accusation, but Q., and that the accusation was made not against him, but about O. X., the Academician. If, however, he, P., accuses him, Gabriel, of back-biting, P. must be perfectly aware that this is not the case, he, Gabriel, having only said a few words against P.'s wife's mother, who is a damned old cat. And so the correspondence continues, Jones and Swinburne and Marshall and William Rossetti and Charles Augustus Howell and a great many more joining in the fray, until at last everybody withdraws all the charges, six months having passed, and Brown invites all the contestants to dinner, Gabriel intending to bring old Plint, the picture-buyer, and to make him, when he has had plenty of wine, buy P.'s picture of the 'Lost Shepherd' for two thousand pounds.

These tremendous quarrels, in fact, were all storms in tea-cups, and although the break-up of the 'Firm' did cause a comparatively lasting estrangement between several of the partners, it has always pleased me to remember that at the last private view that Madox Brown held of one of his pictures every one of the surviving Pre-Raphaelite brothers came to his studio, and every one of the surviving partners of the original firm of Morris & Company.

The arrival of Sir Edward Burne-Jones and his wife brought up a characteristic passion of Madox Brown's. Sir Edward had persuaded the President of the Royal Academy to accompany them in their visit. They were

actuated by the kindly desire to give Madox Brown the idea that thus at the end of his life the Royal Academy wished to extend some sort of official recognition to a painter who had persistently refused for nearly half a century to recognize their existence. Unfortunately it was an autumn day and the twilight had set in very early. Thus not only were the distinguished visitors rather shadowy in the dusk, but the enormous picture itself was entirely indistinguishable. Lady Burne-Jones, with her peculiarly persuasive charm, whispered to me, unheard by Madox Brown, that I should light the studio gas, and I was striking a match when I was appalled to hear Madox Brown shout, in tones of extreme violence and of apparent alarm:

'Damn and blast it all, Fordie! Do you want us all blown into the next world?'

And he proceeded to explain to Lady Burne-Jones that there was an escape of gas from a pipe. When she suggested candles or a paraffin-lamp, Madox Brown declared with equal violence that he couldn't think how she could imagine that he could have such infernally dangerous things in the house. The interview thus concluded in a gloom of the most tenebrous, and shortly afterwards he went downstairs, where, in the golden glow of a great many candles set against a golden and embossed wall-paper, tea was being served. The fact was that Madox Brown was determined that no 'damned Academician' should see his picture. Nevertheless, it is satisfactory to me to think that there was among these distinguished and kindly men still so great a feeling of solidarity. They had come, many of them, from great distances, to do honour, or at least to be kind, to an old painter who at that time was more entirely forgotten than he has ever been before or since.

The lily tradition of the disciples of these men is, I should imagine, almost entirely extinguished. But the other day, at a particularly smart wedding, there turned up one staunch survivor in garments of prismatic hues—a

mustard-coloured ulster, a green wide-awake, a blue shirt, a purple tie and a suit of tweed. This gentleman moved distractedly among groups of correctly attired people. In one hand he bore an extremely minute painting by himself. It was, perhaps, of the size of a visiting-card, set in an ocean of white mount. In the other he bore an enormous spray of Madonna-lilies. That, I presume, was why he had failed to remove his green hat. He was approached by the hostess and he told her that he wished to place the picture, his wedding-gift, in the most appropriate position that could be found for it. And upon her suggesting that she would attend to the hanging after the ceremony was over, he brushed her aside. Finally he placed the picture upon the ground beneath a tall window, and perched the spray of lilies on top of the frame. He then stood back and, waving his emaciated hands and stroking his brown beard, surveyed the effect of his decoration. The painting, he said, symbolized the consolation that the arts would afford the young couple during their married life, and the lily stood for the purity of the bride. This is how in the seventies and the eighties the outer ring of the aesthetes really behaved. It was as much in their note as were the plum-pudding and the roast beef in William Morris's. The reason for this is not very far to seek. The older men, the Pre-Raphaelites, and the members of the 'Firm' had too rough work to do to bother much about the trimmings.

It is a little difficult now-a-days to imagine the acridity with which any new artistic movement was opposed when Victoria was Queen of England. Charles Dickens called loudly for the immediate imprisonment of Millais and the other Pre-Raphaelites, including my grandfather, who was not a Pre-Raphaelite. Blasphemy was the charge alleged against them, just as it was the charge alleged against the earliest upholders of Wagner's music in England. This may seem incredible, but I have in my possession three letters from three different members of the public addressed to my father, Dr Francis Hueffer, a man of

great erudition and force of character, who, from the early seventies until his death, was the musical critic of *The Times*. The writers stated that unless Doctor Hueffer abstained from upholding the blasphemous music of the future—and in each case the writer used the word blasphemous—he would be respectively stabbed, ducked in a horse-pond and beaten to death by hired roughs. Yet to-day I never go to a place of popular entertainment where miscellaneous music is performed for the benefit of the poorest classes without hearing at least the overture to *Tannhäuser*. Now-a-days it is difficult to discern any new movement in any of the arts. No doubt there is movement, no doubt we who write and our friends who paint and compose are producing the arts of the future. But we never have the luck to have the word 'blasphemous' hurled at us. It would, indeed, be almost inconceivable that such a thing could happen, that the frame of mind should be reconstructed. But to the Pre-Raphaelites this word was blessed in the extreme. For human nature is such—perhaps on account of obstinacy or perhaps on account of feelings of justice—that to persecute an art, as to persecute a religion, is simply to render its practitioners the more stubborn and its advocates in their fewness the more united, and the more effective in their union. It was the injustice of the attack upon the Pre-Raphaelites, it was the fury and outcry, that won for them the attention of Mr Ruskin. And Mr Ruskin's attention being aroused, he entered on that splendid and efficient championing of their cause which at last established them in a position of perhaps more immediate importance than, as painters, they exactly merited. As pioneers and as sufferers they can never sufficiently be recommended. Mr Ruskin, for some cause which my grandfather was used to declare was purely personal, was the only man intimately connected with these movements who had no connection at all with Madox Brown. I do not know why this was, but it is a fact that, although Madox Brown's pictures were in considerable evidence at all places where

the pictures of the Pre-Raphaelites were exhibited, Mr Ruskin in all his works never once mentioned his name. He never blamed him; he never praised him; he ignored him. And this was at a time when Ruskin must have known that a word from him was sufficient to make the fortune of any painter. It was sufficient not so much because of Mr Ruskin's weight with the general public as because the small circle of buyers, wealthy and assiduous, who surrounded the painters of the moment, hung upon Mr Ruskin's lips and needed at least his printed sanction for all their purchases.

Madox Brown was the most benevolent of men, the most helpful and the kindest. His manifestations, however, were apt at times to be a little thorny. I remember an anecdote which Madox Brown's housemaid of that day was in the habit of relating to me when she used to put me to bed. Said she—and the exact words remain upon my mind:

'I was down in the kitchen waiting to carry up the meat, when a cabman comes down the area steps and says: "I've got your master in my cab, He's very drunk." I says to him'—and an immense intonation of pride would come into Charlotte's voice—'My master's a-sitting at the head of his table entertaining his guests. That's Mr Swinburne. Carry him upstairs and lay him in the bath.'

Madox Brown, whose laudable desire it was at many stages of his career to redeem poets and others from dipsomania, was in the habit of providing several of them with labels upon which were inscribed his own name and address. Thus, when any of these geniuses were found incapable in the neighbourhood they would be brought by cabmen or others to Fitzroy Square. This, I think, was a stratagem more characteristic of Madox Brown's singular and quaint ingenuity than any that I can recall. The poet being thus recaptured would be carried upstairs by Charlotte and the cabman and laid in the bath—in Colonel Newcome's very bath-room, where, according to Thackeray, the water moaned and gurgled so mournfully in the

cistern. For me, I can only remember that room as an apartment of warmth and lightness; it was a concomitant to all the pleasures that sleeping at my grandfather's meant for me. And indeed, to Madox Brown as to Colonel Newcome—they were very similar natures in their chivalrous, unbusinesslike and naïve simplicity—the house in Fitzroy Square seemed perfectly pleasant and cheerful.

The poet having been put into the bath would be reduced to sobriety by cups of the strongest coffee that could be made (the bath was selected because he would not be able to roll out and to injure himself). And having been thus reduced to sobriety, he would be lectured, and he would be kept in the house, being given nothing stronger than lemonade to drink, until he found the régime intolerable. Then he would disappear, the label sewn inside his coat-collar, to reappear once more in the charge of a cabman.

Of Madox Brown's acerbity I witnessed myself no instances at all, unless it be the one that I have lately narrated. A possibly too-stern father of the old school, he was as a grandfather extravagantly indulgent. I remember his once going through the catalogue of his grandchildren and deciding, after careful deliberation, that they were all geniuses with the exception of one, as to whom he could not be certain whether he was a genius or mad. Thus I read with astonishment the words of a critic of distinction with regard to the exhibition of Madox Brown's works that I organized at the Grafton Gallery ten years ago. They were to the effect that Madox Brown's pictures were very crabbed and ugly—but what was to be expected of a man whose disposition was so harsh and distorted? This seemed to me to be an amazing statement. But upon discovering the critic's name I found Madox Brown once kicked him downstairs. The gentleman in question had come to Madox Brown with the proposal from an eminent firm of picture-dealers that the painter should sell all his works to them for a given number of years at a very low price. In return they were to do what

would be called now-a-days 'booming' him, and they would do their best to get him elected an associate of the Royal Academy. That Madox Brown should have received with such violence a proposition that seemed to the critic so eminently advantageous for all parties justified that gentleman in his own mind in declaring that Madox Brown had a distorted temperament. Perhaps he had.

But if he had a rough husk he had a sweet kernel, and for this reason the gloomy house in Fitzroy Square did not, I think, remain as a shape of gloom in the minds of many people. It was very tall, very large, very grey, and in front of it towered up very high the mournful plane-trees of the square. And over the porch was the funeral urn with the ram's head. This object, dangerous and threatening, has always seemed to me to be symbolical of this circle of men, so practical in their work and so romantically unpractical, as a whole, in their lives. They knew exactly how, according to their lights, to paint pictures, to write poems, to make tables, to decorate pianos, rooms or churches. But as to the conduct of life they were a little sketchy, a little romantic, perhaps a little careless. I should say that of them all Madox Brown was the most practical. But his way of being practical was always to be quaintly ingenious. Thus we had the urn. Most of the Pre-Raphaelites dreaded it; they all of them talked about it as a possible danger, but never was any step taken for its removal. It was never even really settled in their minds whose would be the responsibility for any accident. It is difficult to imagine the frame of mind, but there it was, and there to this day the urn remains. The question could have been settled by any lawyer, or Madox Brown might have had some clause that provided for his indemnity inserted in his lease. And, just as the urn itself set the tone of the old immense Georgian mansion fallen from glory, so perhaps the fact that it remained for so long the topic of conversation set the note of the painters, the painter-poets, the poet-craftsmen, the painter-musicians, the fili-buster verse-writers, and all that singular collection of men

versed in the arts. They assembled and revelled comparatively modestly in the rooms where Colonel Newcome and his fellow-directors of the Bundelcund Board had partaken of mulligatawny and spiced punch before the side-board that displayed its knife-boxes with the green-handled knives in their serried phalanxes.

But, for the matter of that, Madox Brown's own side-board also displayed its green-handled knives, which always seemed to me to place him as the man of the old school in which he was born and remained to the end of his days. If he was impracticable, he hadn't about him a touch of the Bohemian; if he was romantic, his romances took place along ordered lines. Every friend's son of his who went into the navy was destined to his eyes to become, not a pirate, but at least a port-admiral. Every young lawyer that he knew was certain, even if he were only a solicitor, to become Lord Chancellor, and every young poet who presented him with a copy of his first work was destined for the Laureateship. And he really believed in these romantic prognostications, which came from him without end as without selection. So that if he was the first to give a helping hand to D. G. Rossetti, his patronage in one or two other instances was not so wisely bestowed.

He was, of course, the sworn foe of the Royal Academy. For him they were always, the members of that august body, 'those *damned* Academicians,' with a particular note of acerbity upon the expletive. Yet I very well remember, upon the appearance of the first numbers of *The Daily Graphic*, that Madox Brown, being exceedingly struck by the line-engravings of one of the artists that paper regularly employed to render social functions, exclaimed:

'By Jove! if young Cleaver goes on as well as he has begun, those damned Academicians, supposing they had any sense, would elect him President right away!' Thus it will be seen that the business of romance was not to sweep away the Royal Academy, was not to found an opposing salon, but it was to capture the established body by storm, leaping, as it were, on to the very quarter-deck,

and setting to the old ship a new course. The characteristic, in fact, of all these men was their warm-heartedness, their enmity for the formal, for the frigid, for the ungenerous. It cannot be said that any of them despised money. I doubt whether it would even be said that any of them did not, at one time or another, seek for popularity, or try to paint, write or decorate pot-boilers. But they were naïvely unable to do it. To the timid—and the public is always the timid—what was individual in their characters was always alarming. It was alarming even when they tried to paint the conventional dog-and-girl pictures of the Christmas supplement. The dogs were too like dogs and did not simper; the little girls were too like little girls. They would be probably rendered as just losing their first teeth.

In spite of the Italianism of Rossetti, who was never in Italy, and the medievalism of Morris, who had never looked medievalism, with its cruelties, its filth, its stenches and its avarice, in the face—in spite of these tendencies that were forced upon them by those two contagious spirits, the whole note of this old, romantic circle was national, was astonishingly English, was Georgian even. They seemed to date from the Regency, and to have skipped altogether the baneful influence of early Victorianism and of the commerciality that the Prince Consort spread through England. They seem to me to resemble in their lives—and perhaps in their lives they were greater than their works—to resemble nothing so much as a group of old-fashioned ships' captains. Madox Brown, indeed, was nominated for a midshipman in the year 1827. His father had fought on the famous *Arethusa* in the classic fight with the *Belle Poule*. And but for the fact that his father quarrelled with Commodore Coffin, and so lost all hope of influence at the Admiralty, it is probable that Madox Brown would never have painted a picture or have lived in Colonel Newcome's house. Indeed, on the last occasion when I saw William Morris I happened to meet him in Portland Place. He was going to the house

of a peer, that his firm was engaged in decorating, and he took me with him to look at the work. He was then a comparatively old man, and his work had grown very flamboyant, so that the decoration of the dining-room consisted, as far as I can remember, of one huge acanthus-leaf design. Morris looked at this absent-mindedly, and said that he had just been talking to some members of a ship's crew whom he had met in Fenchurch Street. They had remained for some time under the impression that he was a ship's captain. This had pleased him very much, for it was his ambition to be taken for such a man. I have heard, indeed, that this happened to him on several occasions, on each of which he expressed an equal satisfaction. With a grey beard like the foam of the sea, with grey hair through which he continually ran his hands, erect and curly on his forehead, with a hooked nose, a florid complexion and clean, clear eyes, dressed in a blue serge coat, and carrying, as a rule, a satchel, to meet him was always, as it were, to meet a sailor ashore. And that in essence was the note of them all. When they were at work they desired that everything they did should be ship-shape; when they set their work down they became like Jack ashore. And perhaps that is why there is, as a rule, such a scarcity of artists in England. Perhaps to what is artistic in the nation the sea has always called too strongly.

## PRINCIPLES

I should say that Rossetti was a man without any principles at all, who earnestly desired to find some means of salvation along the lines of least resistance. Madox Brown, on the other hand, was ready to make a principle out of anything that was at all picturesque.

## THE CHINESE TEA-THINGS

Rossetti wanted to fill his house with anything that was odd, Chinese or sparkling. If there was something gruesome about it, he liked it all the better. Thus, at his death, two marauders out of the shady crew that victimized him, and one honest man, each became possessed of the dark-lantern used by Eugene Aram. I mean to say that quite lately there were in the market three dark-lanterns, each of which was supposed to have come from Rossetti's house at his death, only one of which had been bought with honest money at Rossetti's sale. Even this one may not have been the relic of the murderer which Rossetti had purchased with immense delight. He bought, in fact, just anything or everything that amused him or tickled his fancy, without the least idea of making his house resemble anything but an old curiosity shop.

This collection was rendered still more odd by the eccentricities of Mr Charles Augustus Howell, an extraordinary personage who ought to have a volume all to himself. There was nothing in an odd-jobbing way that Mr Howell was not up to. He supported his family for some time by using a diving-bell to recover treasure from a lost galleon off the coast of Portugal, of which country he appears to have been a native. He became Ruskin's secretary, and he had a shop in which he combined the framing and the forging of masterpieces. He conducted the most remarkable of dealers' swindles with the most consummate ease and grace, doing it, indeed, so loveably that when his misdeeds were discovered he became only more beloved. Such a character would obviously appeal to Rossetti, and as, at one period of his career, Rossetti's income ran well into five figures, while he threw gold out of all the windows and doors, it is obvious that such a character as Rossetti's must have appealed very strongly to Mr Charles Augustus Howell. The stories of him are endless.

At one time, while Rossetti was collecting *chinoiseries*, Howell happened to have in his possession a nearly priceless set of Chinese tea-things. These he promptly proceeded to have duplicated at his establishment where forging was carried on more wonderfully than seems possible. This forgery he proceeded to get one of his concealed agents to sell to Rossetti for an enormously high figure. Coming to tea with the poet-artist on the next day, he remarked to Rossetti:

'Hello, Gabriel! where did you get those clumsy imitations?'

Rossetti, of course, was filled with consternation, whereupon Howell remarked comfortingly: 'Oh, it's all right, old chap, I've got the originals, which I'll let you have for an old song.'

And, eventually, he sold the originals to Rossetti for a figure very considerably over that at which Rossetti had bought the forgeries. Howell was then permitted to take away the forgeries as of no value, and Rossetti was left with the originals. Howell, however, was for some time afterward more than usually assiduous in visiting the painter-poet. At each visit he brought one of the forged cups in his pocket, and while Rossetti's back was turned he substituted the forgery for one of the genuine cups, which he took away in his pocket. At the end of the series of visits, Rossetti once more possessed the copies and Howell the genuine set, which he sold, I believe, to M. Tissot.

## A LION IN THE STRAND

I had a very elderly and esteemed relative who once told me that while walking along the Strand he met a lion that had escaped from Exeter Change.* I said, 'What did you

* The site of a menagerie in the sixties and seventies of the last century.

do?' and he looked at me with contempt as if the question were imbecile. '*Do?*' he said. 'Why, I took a cab.'

## MY OLD NURSE ATTERBURY

My old nurse Atterbury was married to a descendant of the great Atterbury of Rochester; her daughter to one of the great Racine's. Thus even in the lower part of the house I lived among resounding names whilst the great of those days—at least in the arts—thundered and declaimed upstairs.

M. Racine, the cook's husband, had been a member of the Commune in 1870. He was a striking, very tall man, with an immense hooked nose that leaned to one side and blank, black, flashing eyes. I used to listen to his declamations against MacMahon and Gambetta with a great deal of edification. He must have been the first politician of the extreme Left that I ever listened to, but about the same time I must have had my first lessons in French literature from a M. Andrieux *fils*. He was another Communard. He comes back to me as the most elegant man I ever knew. His little moustaches were most comically waxed and he had the enviable gift of being able to make two cigarettes at once. The crook to the right of M. Racine's nose I always put down to the Versaillais troops, figuring that they had done it with an immense paper-clip. Thus I early developed a hatred for tyrants and a love for lost causes and exiles that still, I hope, distinguish me. Poland, Alsace-Lorraine, Ireland and even the Jews exiled from their own country—those were the names of romance of my childhood. They so remain for me.

My nurse, Mrs Atterbury, had one singularity; she had come in contact with more murders and deaths by violence than any person I ever met—at any rate until 1914. In consequence, I imagine, my childhood was haunted by imaginary horrors and was most miserable. I can still see

the shadows of wolves if I lie awake in bed with a fire in the room. And indeed I had the fixed belief for years that except for myself the world was peopled with devils. I used to peep through the cracks of doors to see the people within in their natural forms.

Mrs Atterbury had been in the great railway accident near Doncaster where innumerable persons were burned to death; she had seen seven people run over and killed and her milder conversations abounded in details of deaths by drowning. I don't think she was present at the sinking of the *Princess Alice* but she talked about it as if she had been. Her normal conversations ran:

'When I lived with me yuncle Power in the Minories time of the Crimea wower, me yuncle let 'is top front to a master saddler. 'N' wen wower broke out the master saddler 'e worked niteanday fer sevin weeks without stop er stay. 'N' 'e took 'is saddles to the Wower Orfis 'n' drawed 'is pay. All in gowlden sovrins in a Gledstun beg. 'N' wen 'e got 'ome 'e cut 'is froat on the top front landin' 'n' the blood 'n' the gowld run down the staircase together like the awtificial cascades in Battersea Pawk.' ... 'The blood 'n' the gowld!' she would repeat and catch my wrist in her skinny fingers.

She was a witness—or an almost-witness—of one of the Jack-the-Ripper murders in Whitechapel. She certainly came on the body of one of the victims and claimed to have seen a man vanish into the fog. I never actually heard the details of that. My mother, worried by the advent of a questioning police-sergeant and the hysterics of the household below stairs, forbade the old lady to tell us children about it. But her impressive and mysterious absence in her best black bonnet and jet-beaded cloak, and the whispers of the household made me fully aware that she was giving evidence at the Inkwedge. For long afterwards heaven knew what horrors were not concealed for me in the pools of shadow beneath the lamp-posts. In solitary streets her footsteps echoing and a smudge of fog in the gaslight!

The last time I saw the old lady she was sitting—as she did day in day out for years—in the window of a parlour that occupied the apex of a corner lot in an outer suburb. She could look right up and down two long streets.

She greeted me with great vivacity. The day before there had been a tremendous thunderstorm. The streets up which she looked had been almost obscured by falling water. She said to me:

'I calls out to Lizzie. . . . Good gracious me! That man! 'E's struck dead! . . . 'N' 'e *was*!' she added triumphantly.

## CREATURES FRAIL BUT AWFUL

The poet—and still more the poetess—of the seventies and eighties, though an awful, was a frail creature, who had to be carried about from place to place, and generally in a four-wheeled cab. Indeed, if my recollection of these poetesses in my very earliest days was accompanied always by thunders and expostulations, my images of them in slightly later years, when I was not so strictly confined to the nursery—my images of them were always those of somewhat elderly ladies, forbidding in aspect, with grey hair, hooked noses, flashing eyes and continued trances of indignation against reviewers. They emerged ungracefully—for no one ever yet managed to emerge gracefully from the door of a four-wheeler—sometimes backward, from one of those creaking and dismal tabernacles and pulling behind them odd-shaped parcels. Holding the door open, with his whip in one hand, would stand the cabman. He wore an infinite number of little capes on his overcoat; a grey worsted muffler would be coiled many times round his throat, and the lower part of his face and his top hat would be of some unglossy material that I have never been able to identify. After a short interval, his hand would become extended, the flat palm displaying such coins as the poetess had laid in it. And, when the

poetess with her odd bundles was three-quarters of the way up the door-steps, the cabman, a man of the slowest and most deliberate, would be pulling the muffler down from about his mouth and exclaiming: 'Wot's this?'

The poetess, without answering, but with looks of enormous disdain, would scuffle into the house and the front door would close. Then upon the knocker the cabman would commence his thunderous symphony.

Somewhat later more four-wheelers would arrive with more poetesses. Then still more four-wheelers with elderly poets; untidy-looking young gentlemen with long hair and wide-awake hats, in attitudes of dejection and fatigue, would ascend the steps; a hansom or two would drive up containing rather smarter, stout, elderly gentlemen wearing as a rule black coats with velvet collars and most usually black gloves. These were reviewers, editors of *The Athenaeum* and of other journals. Then there would come quite smart gentlemen with an air of prosperity in their clothes and with deference somewhat resembling that of undertakers in their manners. These would be publishers.

You are to understand that what was about to proceed was the reading to this select gathering of the latest volume of poems by Mrs Clara Fletcher—that is not the name—the authoress of what was said to be a finer sequence of sonnets than those of Shakespeare. And before a large semicircle of chairs occupied by the audience that I have described, and with Mr Clara Fletcher standing obsequiously behind her to hand to her from the odd-shaped bundles of manuscripts the pages that she required, Mrs Clara Fletcher, with her regal head regally poised, having quelled the assembly with a single glance, would commence to read.

Mournfully then, up and down the stone staircases, there would flow two hollow sounds. For, in those days, it was the habit of all poets and poetesses to read aloud upon every possible occasion, and whenever they read aloud to employ an imitation of the voice invented by the late

Lord Tennyson and known, in those days, as the *ore rotundo*—'with the round mouth mouthing out their hollow o's and a's.'

The effect of this voice heard from outside a door was to a young child particularly awful. It went on and on, suggesting the muffled baying of a large hound that is permanently dissatisfied with the world. And this awful rhythm would be broken in upon from time to time by the thunders of the cabman. How the housemaid—the housemaid was certainly Charlotte Kirby—dealt with this man of wrath I never could rightly discover. Apparently the cabman would thunder upon the door. Charlotte, keeping it on the chain, would open it for about a foot. The cabman would exclaim. 'Wot's this?' and Charlotte would shut the door in his face. The cabman would remain inactive for four minutes in order to recover his breath. Then once more his stiff arm would approach the knocker and again the thunders would resound. The cabman would exclaim: 'A bob and a tanner from the Elephant and Castle to Tottenham Court Road!' and Charlotte would again close the door in his face. This would continue for perhaps half an hour. Then the cabman would drive away to meditate. Later he would return and the same scenes would be gone through. He would retire once more for more meditation and return in the company of a policeman. Then Charlotte would open the front door wide and by doing no more than ejaculating, 'My good man!' she would appear to sweep out of existence policeman, cab, cab-horse, cabman and whip, and a settled peace would descend upon the house, lulled into silence by the reverberation of the hollow o's and a's. In about five minutes' time the policeman would return and converse amiably with Charlotte for three-quarters of an hour through the area railings. I suppose that was really why cabmen were always worsted and poetesses protected from these importunities in the dwelling over whose destinies Charlotte presided for forty years.

The function that was proceeding behind the closed

doors would now seem incredible; for the poetess would read on from two to three and a half hours. At the end of this time—such was the fortitude of the artistic when Victoria was still the Widow at Windsor—an enormous high babble of applause would go up. The forty or fifty poetesses, young poets, old poets, painter-poets, reviewers, editors of *Athenaeums* and the like would divide themselves into solid bodies, each body of ten or twelve surrounding one of the three or four publishers and forcing this unfortunate man to bid against his unfortunate rivals for the privilege of publishing this immortal masterpiece. My grandfather would run from body to body, ejaculating: 'Marvellous genius!' 'First woman poet of the age!' 'Lord Tennyson himself said he was damned if he wasn't envious of the sonnet to Mehemet Ali!'

Mr Clara Fletcher would be trotting on tiptoes fetching for the lady from whom he took his name—now exhausted and recumbent in a deep arm-chair—smelling-bottles, sponges full of aromatic vinegar to press upon her brow, glasses of sherry, thin biscuits, and raw eggs in tumblers. As a boy I used to think vaguely that these comestibles were really nectar and ambrosia.

In the early days I was only once permitted to be present at these august ceremonies. I say I was permitted to be present, but actually I was caught and forced very much against my will to attend the rendition by my aunt, Lucy Rossetti, who, with persistence, that to me at the time appeared fiendish, insisted upon attempting to turn me into genius too. Alas! hearing Mr Arthur O'Shaughnessy read 'Music and Moonlight' did not turn poor little me into a genius. It sent me to sleep, and I was carried from the room by Charlotte, disgraced and destined from that time forward only to hear those hollow sounds from the other side of the door. Afterward I should see the publishers, one proudly descending the stairs, putting his chequebook back into his overcoat pocket, and the others trying vainly to keep their heads erect under the glances of scorn that the rest of the departing company poured upon

them. And Mr Clara Fletcher would be carefully folding the cheque into his waist-coat pocket, while his wife, from a large reticule, produced one more eighteenpence wrapped up in tissue-paper.

## CHARLOTTE'S CONVERSATIONS

I do not know how many of my details of the lives of the great of the early eighties do not come to me from listening, unobserved, to Charlotte's conversations with my mother in the great linen-room of the Fitzroy Square house.... Long, quiet monologues about Mr Swinburne and Mrs Lizzie Rossetti and the carryings on of Mr Rossetti and that Mr Burne-Jones and *that* Mrs Ruskin, poor dear thing.... Her husband says to her on their wedding-day as they drove away in their carriage.... A shame I calls it.... And the Queen acting so cruel! ... Fair threw the President's chain in Sir Everett's face as he knelt before her, they say she did.... And her such a pretty thing when she was Miss Euphemia Grey.... But he never forgive your father, Mr Ruskin didn't.... Always thought he connived because, the night they eloped, your father had him to dinner.... Charlotte twice had Queen Alexandra's prize for having been longest in any family in the kingdom ... after sixty years of it and after seventy.... When she was eighty-two she was sitting on a bench on Primerose Ill and a gentleman sat down beside er an says e ad the nest and e wanted a little bird to put in it and ad she any savins? ... Threw er bonnet in is face she did 'n' tole im what she thought v im.... I bet his ears burned!

The great seen from the linen-room were thus diminished for me—the awful, monumental, minatorily bearded tumultuous and moral Great of those days.... Insupportably moral they were, and I imagine the sense of original sin that in those days possessed me in their presences would have overwhelmed me altogether but for

the moral support that the anecdotes in the linen-room afforded me.

To stand, say, at the age of eleven between the painter of the 'Light of the World,' Mr Holman Hunt, and Mr Ruskin would have been an insupportable ordeal. Mr Hunt had a voice like a creaking door, endlessly complaining; in moments of virtuous emotion Mr Ruskin fairly hissed like an adder.... The whole world had conspired to misjudge, vilify, misrepresent, misunderstand, misestimate ... even to rob, both of them, singly and together. It was as if they were mountainous islands entirely surrounded by villains. Mr Hunt would creak:

'Gabriel ... Gabriel was nothing but a thief.... A common sneak-thief. I could have had him up before the magistrate at Bow Street. At any moment.'

Mr Ruskin would dither, 'Dear, dear, dear, dear!'

'At any moment,' Mr Hunt would repeat. 'He borrowed my copy of Browne's *Hydriotaphia* with Flaxman's plates ... worth three pun ten, at least ... and never returned it.... A common vulgar sneak-thief....'

I heard Mr Hunt use those very words not so long after his friend Rossetti's death.... If I think about it hard it was perhaps not to Mr Ruskin but to Lord Justice Ford North, who was the only human being I ever knew who was more disagreeable than Mr Ruskin. He would, in moments of fury, snatch off his wig and throw it in the face of his Clerk of the Court. He was a militant churchman and was translated from the King's Bench to the Court of Chancery because he sentenced Foote the Atheist to penal servitude for life ... for denying in a penny pamphlet the existence of the Deity....

Well, they were that sort of alarming persons for a little boy ... the members of the Pre-Raphaelite circle, and certainly their society would have been an insupportable ordeal if I hadn't been able, when they weren't looking at me, to squint sideways into their faces and say to myself:

'Ah, yes, you're Mr Ruskin.... My grandfather says

you look like a cross between a fiend and a tallow-chandler and Charlotte says. . . .' Well, I have already adumbrated what Charlotte said of Mr Ruskin. . . . What she said of Mr Hunt would not bear even adumbration but it was very fortifying for me. . . . As for the Judge I never heard anything worse of him than that he suffered from an internal ulcer, which was what made him so obstreperous. He once cursed Charlotte at the top of his voice all the way from the studio to the front door. . . . But she had seemed rather to like it. Collected burial urns, he did. . . .

But as for Mr Swinburne. . . . Ah, that! . . .

I don't know whether it was Charlotte's adoration for him or whether I worked it out for myself. . . . But he at least was a solar myth with the voice of a Greek god, beautiful and shining and kind so that when *he* came on the scene, drunk or sober, all was gas and gingerbread and joy-bells and jujubes. . . . Well, he used to give me jujubes, slipping them out of his waistcoat pocket in his beautiful, long, white fingers. . . . And now and then it would be a poem suited to my comprehension and written in his beautiful clear hand, minutely, on valentine paper with lacey edgings and Father Christmas embossed on the reverse, or pink roses. . . . Usually, as far as I can remember, about my dog Dido . . . rhyming 'dog' with 'fog' and 'bog'. . . . I think Mr Swinburne once came on me on Wimbledon Common, which was near my birth-place, on a misty day, immensely distressed because my dog Dido had gone into one of the ponds and would not come out. . . . So Mr Swinburne wrote me a series of little jingles about the adventures of that faithful hound, and used to deliver them furtively as if he were slipping me little parcels of candy. . . .

He was like that to children—and I daresay to grown-ups. And if you think that his coming home occasionally in four-wheel cabs from which he had to be conveyed upstairs to the bath-room . . . if you think that that made any difference to my—or even Charlotte's—childish adoration, you are mistaken indeed. . . . It didn't make

even any difference to me that he was unduly short in stature. When the door opened before him and you looked to see a man's head appear at about the middle of the upper panel, his chin would not be much above the level of the door-handle . . . not much. But then it was such a glorious head that you immediately forgot.

And then he was so much the great gentleman . . . which is a thing as to which the servants' hall and the nursery never make mistakes. He was one of the great, ruffian Swinburnes of the Border . . . with the Eliots and Crasters and Armstrongs and Jocks o' Hazeldean, reiving the cattle and burning the towers of the fause Scots, for ever in revolt against the Tudors, giving their lives in defence of Mary Stewart, chronicled in all the border ballads from Chevy Chase to Preston Pans. . . .

It meant nothing to me that Mr Swinburne had occasionally to be carried past between Charlotte and a keb-man. . . . For the matter of that Charlotte would have carried him all by herself. . . . And you should have heard her defending him in the linen-room.

'That Mrs Lizzie Rossetti,' she used to exclaim. 'If the poor dear young gentleman wants to drink, why shouldn't e? . . . Not that e drinks like Mr Blank does . . . not to say soak. . . . No, he gits rearing tearing boosed when e as the mind ter . . . n calls for pen n paper in the bath n writes n ode. . . . E wrote two last Friday as ever was. . . . To Mister Mazzini n against the Emperor of the French. . . . N why shouldn't e? . . . That Mrs Lizzie Rossetti. . . . A powerful pernicketty lady *she* was. N would have things jest so. . . . Why shouldn't e git drunk in er box at Common Garden Oppra if he ad the mind? If so be s she ed bin faithful to er usband she might have spoken. . . . But she must go n take n overdose'v opium. . . . Onreasonable I call it. . . . Now look here Miss Catherine. . . .' My mother was Miss Catherine for her until her death . . . and to her death her Mr Swinburne was more sinned against than . . . but no, for her he never sinned at all. . . . It was all that Mrs Lizzie

Rossetti's fault . . . when it wasn't the indigestion, all them poor fellows avin no one to look after ther meals.

I suppose it to be generally known to the world interested in such matters that Swinburne entertained a passion for Mrs D. G. Rossetti—the Elizabeth Siddal of earlier days, the model for Millais's *Ophelia*, the Félise of Swinburne's ballad. . . . The famous Miss Siddal, in short.* According to Charlotte his interest was reciprocated by the lady to the extent of her being ready to elope with Swinburne. . . . Though, Charlotte used to say, it was astonishing that anyone so cold-blooded and hearted as Mrs Lizzie, should want to elope with anyone. And on the night before the planned elopement Mr and Mrs Rossetti were in a box at the opera and Swinburne joined them in a state of inebriation so insupportable that Mrs Rossetti went home and took an overdose of some opiate. . . .

There were, of course, in Charlotte's account other gloomy and harrowing details of miscarriages and misunderstandings in a lugubriously oil-lamp-lit, indigestion-ridden, gin-sodden, always dripping London of the seventies —than which city none other could be imagined less suited for the sports and loves of lyric balladists of origin whether North Country or Italian. . . . On those you can employ your imaginations to any extent or, as to them, read legions of other writers. . . . The reports of the inquest —which Charlotte needless to say attended—state duly that before taking her overdose Mrs Rossetti had been at the Opera with Mr Rossetti and Mr Swinburne . . . and the coroner and jury passed a vote of sympathy for Mr Rossetti, thus left without anyone to sew on his shirt-buttons. But they say nothing of Mr Swinburne's intoxication, which you can take or not as you please.

The point is that neither for Charlotte nor for me did any of these lugubriousnesses in the least dim the shine of the figure of Swinburne, the great little gentleman. He

* Who was known as Guggums (!) to the inner circle of the Brotherhood.

remained for us the glorious, reckless Border cattle-reiver, champion of Mary Queen o' Scots and of Liberty, Hellene, near-Godhead, golden in voice, infinitely chivalrous. . . .

## PRE-RAPHAELITE LOVE

Love, according to the Pre-Raphaelite canon, was a great but rather sloppy passion. Its manifestations would be Paolo and Francesca, or Launcelot and Guinevere. It was a thing that you swooned about on broad, general lines, your eyes closed, your arms outstretched. It excused all sins, it sanctified all purposes, and if you went to hell over it you still drifted about among snow-flakes of fire with your eyes closed and in the arms of the object of your passion. For it is impossible to suppose that when Rossetti painted his picture of Paolo and Francesca in hell, he or any of his admirers thought that these two lovers were really suffering. They were not. They were suffering perhaps with the malaise of love, which is always an uneasiness, but an uneasiness how sweet! And the flakes of flames were descending all over the rest of the picture, but they did not fall upon Paolo and Francesca. No, the lovers were protected by a generalized swooning passion that formed, as it were, a moral and very efficient mackintosh all over them. And no doubt what D. G. Rossetti and his school thought was that, although guilty lovers have to go to hell for the sake of the story, they will find hell pleasant enough, because the aroma of their passion, the wings of the great god of love, and the swooning intensity of it all will render them insensible to the inconveniences of their lodgings. As much as to say that you do not mind the bad cooking of the Brighton Hotel if you are having otherwise a good time of it.

## MR CARLYLE...AND MR PEPPER

There were all these things jumbled up in my poor little mind together.... I could not think that D. G. Rossetti was a person any more remarkable than the gentleman with gold braid round his hat who opened for me the locked gates of Fitzroy Square, or that when I shook hands with a clergyman called Franz Liszt was it any more of an event than when, as I was enjoined to do, I performed the same ceremony with the cook's husband. Dimly, but with vivid patches, I remember being taken for a walk by my father along what appeared to me to be a grey-stone quay. I presume it was the Chelsea Embankment. There we met a very old, long-bearded man. He frightened me quite as much as any of the other great Victorian figures, who, to the eye of a child, appeared monumental, loud-voiced and distressing. This particular gentleman at the instance of my grandfather related to me how he had once been at Weimar. In a garden restaurant beneath a May-tree in bloom he had seen Schiller and Goethe drinking coffee together. He had given a waiter a thaler to be allowed to put on a white apron and to wait upon these two world-shaking men, who, in court-dress with wigs and swords, sat at a damask-covered table. He had waited upon them. Later, I remember that while I was standing with my father beside the doorstep in Tite Street of the house that he was entering, I fell down and he bent over to assist me to rise. His name was Thomas Carlyle, but he is almost confounded in my mind with a gentleman called Pepper. Pepper very much resembled Carlyle, except that he was exceedingly dirty. He used to sell penny-dreadfuls, which I was forbidden to purchase....

## THAT TERRIBLE WORD 'GENIUS'

Then there was that terrible word 'genius.' I think my grandfather, with his romantic mind, first obtruded it on my infant notice. But I am quite certain that it was my aunt, Mrs William Rossetti, who filled me with a horror of its sound that persists to this day. In school-time the children of my family were separated from their cousins, but in the holidays, which we spent as a rule during our young years in lodging-houses side by side, in places like Bournemouth or Hythe, we were delivered over to the full educational fury of our aunt. For this, no doubt, my benevolent but misguided father was responsible. He had no respect for schoolmasters, but he had the greatest possible respect for his sister-in-law. In consequence, our mornings would be taken up in listening to readings from the poets or in improving our knowledge of foreign tongues. My cousins, the Rossettis, were horrible monsters of precocity. Let me set down here with what malignity I viewed their proficiency in Latin and Greek at ages incredibly small. Thus, I believe, my cousin Olive wrote a Greek play at the age of something like five. And they were perpetually being held up to us—or perhaps to myself alone, for my brother was always very much the sharper of the two—as marvels of genius whom I ought to thank God for merely having the opportunity to emulate. For my cousin Olive's infernal Greek play, which had to do with Theseus and the Minotaur, draped in robes of the most flimsy butter-muslin, I was drilled, a lanky boy of twelve or so, to wander round and round the back drawing-room of Endsleigh Gardens, imbecilely flapping my naked arms before an audience singularly distinguished who were seated in the front room. The scenery, which had been designed and painted by my aunt, was, I believe, extremely beautiful, and the *chinoiseries*,

the fine furniture and the fine pictures were such that, had I been allowed to sit peaceably among the audience, I might really have enjoyed the piece. But it was my unhappy fate to wander round in the garb of a captive before an audience that consisted of Pre-Raphaelite poets, ambassadors of foreign powers, editors, Poets Laureate, and Heaven knows what. Such formidable beings at least did they appear to my childish imagination. From time to time the rather high voice of my father would exclaim from the gloomy depths of the auditorium, 'Speak up, Fordie!' Alas! my aptitude for that sort of sport being limited, the only words that were allotted to me were the Greek lamentation 'Theu! Theu! Theu!' and in the meanwhile my cousin, Arthur Rossetti, who appeared only to come up to my knee, was the hero Theseus, strode about with a large sword, slew dragons and addressed perorations in the Tennysonian 'o' and 'a' style to the candle-lit heavens, with their distant view of Athens. Thank God, having been an adventurous youth, whose sole idea of true joy was to emulate the doings of the hero of a work called *Peck's Bad Boy and His Pa*, or at least to attain to the lesser glories of Dick Harkaway, who had a repeating rifle and a tame black jaguar, and who bathed in gore almost nightly—thank God, I say, that we succeeded in leading our unsuspecting cousins into dangerous situations from which they only emerged by breaking limbs. I seem to remember the young Rossettis as perpetually going about with fractured bones. I distinctly remember the fact that I bagged my cousin Arthur with one collar-bone, broken on a boat-slide in my company, while my younger sister brought down her cousin Mary with a broken elbow, fractured in a stone hall. Olive Rossetti, I also remember with gratification, cut her head open at a party given by Miss Mary Robinson, because she wanted to follow me down some dangerous steps and fell onto a flower-pot. Thus, if we were immolated in butter-muslin fetters and in Greek plays, we kept our own end up a little and we never got hurt. Why, I remember pushing my brother out of a

second-floor window so that he fell into the area, and he didn't have even a bruise to show, while my cousins in the full glory of their genius were never really all of them to-gether quite out of the bone-setter's hands.

My aunt gave us our bad hours with her excellent lessons, but I think we gave her hers; so let the score be called balanced. Why, I remember pouring a lot of ink from the first-storey banisters onto the head of Ariadne Petrici when she was arrayed in the robes of her name-sake, whose part she supported. For let it not be imagined that my aunt Rossetti foisted my cousin Arthur into the position of hero of the play through any kind of maternal jealousy. Not at all. She was just as anxious to turn me into a genius, or to turn *anybody* into a genius. It was only that she had such much better material in her own children.

## MIXING UP NAMES

Nothing can prevent my mixing up names. I suppose I inherit the characteristic from my grandfather, who had it to a dangerous degree. I would come in and say to him:

'Grandpa, I met Lord Leighton in the Park and he sent his regards to you.' He would exclaim with violence· 'Leighton! How dare you be seen talking to him. And how dare he presume to send messages to me. He is the scoundrel who . . .' I would interrupt:

'But, Grandpa, he is the President of the Royal Academy. . . .' He would interrupt in turn: 'Nonsense. I tell you he is the fellow who got seven years for. . . .' A few minutes after he would exclaim:

'Leighton? Oh, Leighton? Why didn't you say Leighton if you meant Leighton. I thought you said Fothergill-Bovey Haines. Of course there is no reason why you should not be civil to Leighton.'

## MY GREAT-GRANDMOTHER'S VIRTUE

My German great-grandmother, the wife of the Bürger-meister of one of the capital cities of Germany, could never get over what appeared to her a disastrous new habit that was beginning to be adopted in Germany towards the end of her life, about 1780. She said that it was sinful, that it was extravagant, that it would lead to the downfall of the German nation. This revolutionary new habit was none other than that of having a dining-room. In those days Germany was so poor a country that even though my great-grandparents were considered wealthy people they were always accustomed to eat their meals in the bedroom. There was, that is to say, only one room and a kitchen in their house. The beds of the whole family were in niches in the walls surrounding the living-room, and it was here that they ate, slept, changed their clothes or received their guests. The families of merchants less wealthy even cooked in their bedrooms. This appeared to my great-grand-mother the only virtuous arrangement. And it was no doubt in the same spirit that Madox Brown considered it a proof of decadent luxury to wash one's hands more than three times a day. Now-a-days, I suppose, we should con-sider my great-grandmother's virtue a disgusting affair, and one that, because it was insanitary, was also immoral, or at least antisocial; whilst my grandfather, who washed his hands only three times a day—before breakfast, lunch and dinner—would be considered as only just scraping through the limits of cleanliness. Yet the price of soap is increasing daily.

## MY FATHER

My father was a man of an encyclopedic knowledge and had a great respect for the attainments of the distinguished.

He used, I remember, habitually to call me 'the patient but extremely stupid donkey.' This phrase occurred in Mavor's spelling-book, which he read as a boy in the city of Münster in Westphalia, where he was born. He had a memory that was positively extraordinary, and a gift of languages no less great. Thus while his native language was German, he was for a long course of years musical critic to *The Times*, London correspondent to the *Frankfurter Zeitung*, London musical correspondent to *Le Menestrel* of Paris, and the *Tribuna*, Rome. He was also, I believe, in his day the greatest authority upon the Troubadours and the Romance Languages, and wrote original poems in modern Provençal, and he was a favourite pupil of Schopenhauer, and the bad boy of his family. He was a doctor of philosophy of Göttingen University, at that time premier university of Germany, though he had made his studies at the inferior institution in Berlin. From Berlin he was expelled because of his remarkable memory. The circumstances were as follows:

My father occupied a room in a hotel which had a balcony overlooking the Spree. In the same hotel, but in the next room, there dwelt the Rector of the university, and it happened that one of the Prussian Princes was to be present at the ceremony of conferring degrees. Thus one evening my father was sitting upon his balcony, while next door the worthy Rector read the address that he was afterward to deliver to the Prince. Apparently the younger members of the institution addressed the Prince before the dons. At any rate, my father, having heard it only once, delivered word for word the Rector's speech to His Royal Highness. The result was that the poor man, who spoke only with difficulty, had not a single word to say, and my father was forthwith expelled without his degree. Being, though freakish, a person of spirit, the same day he took the express to Göttingen and, as a result, in the evening he telegraphed to his mother: 'Have passed for doctor with honors at Göttingen,' to the consternation of his parents, who had not yet heard of his expulsion from Berlin. The

exploit pleased nobody. Berlin did not desire that he should be a doctor at all; Göttingen was disgusted that a student from an inferior university should have passed out on top of their particular tree, and I believe that in consequence in Germany of to-day a student can only take his doctor at his own particular university.

It was at the suggestion of Schopenhauer, or, possibly, because his own lively disposition made parts of Germany too hot to hold him, that Dr Hueffer came to England. He had letters of introduction to various men of letters in England, for, for time out of mind, in the city of Münster the Hueffer family had belonged to the class that battens upon authors. They have been, that is to say, printers and publishers. Following his intention of spreading the light of Schopenhauer in England, that country for which Schopenhauer had so immense a respect, Dr Hueffer founded a periodical called the *The New Quarterly Review*, which caused him to lose a great deal of money and to make cordial enemies among the poets and literary men to whom he gave friendly lifts. I fancy that the only traces of *The New Quarterly Review* are contained in the limerick by Rossetti which runs as follows:

> There was a young German called Huffer,
> A hypochondriacal buffer;
> To shout Schopenhauer
> From the top of a tower
> Was the highest enjoyment of Huffer.

In the seventies and eighties there were cries for the imprisonment alike of the critics who upheld and the artistes who performed the Music of the Future. The compositions of Wagner were denounced as being atheistic, sexually immoral, and tending to further Socialism and the throwing of bombs. Wagnerites were threatened with assassination, and assaults between critics of the rival schools were things not unknown in the foyer of the opera. I really believe that my father, as the chief exponent of Wagner in these islands, did go in some

personal danger. Extraordinary pressures were brought to bear upon the more prominent critics of the day, the pressure coming, as a rule, from the exponents of the school of Italian opera. Thus, at the opening of the opera seasons packing-cases of large dimensions and considerable in number would arrive at the house of the ferocious critic of the chief newspaper of England. They would contain singular assortments of comestibles and of objects of art. Thus I remember half a dozen hams, the special product of some north Italian towns; six cases of Rhine wine, which were no doubt intended to propitiate the malignant Teuton; a reproduction of the Medici Venus in marble, painted with phosphoric paint, so that it gleamed blue and ghostly in the twilight; a case of Bohemian glass, and several strings of Italian sausage. And these packing-cases, containing no outward sign of their senders, would have to be unpacked and then once more repacked, leaving the servants with fingers damaged by nails, and passages littered with straw. Inside would be found the cards of Italian *prime donne*, tenors or basses, newly arrived in London, and sending servile homage to the illustrious critic of the 'Giornale Times.' On one occasion a letter containing bank-notes for fifty pounds arrived from a *prima donna* with a pathetic note begging the critic to absent himself from her first night. Praise from a Wagnerite she considered to be impossible, but she was ready to pay for silence. I do not know whether this letter inspired my father with the idea of writing to the next suppliant that he was ready to accept her present—it was the case of Bohemian glass—but that in that case he would never write a word about her singing. He meant the letter, of course, as a somewhat clumsy joke, but the lady—she was not, however, an Italian— possessing a sense of humour, at once accepted the offer. This put my father rather in a quandary, for Madame H. was one of the greatest exponents of emotional tragic music that there had ever been, and the occasion on which she was to appear was the first performance in England of one of the great operas

of the world. I do not exactly know whether my father went through any conscientious troubles—I presume he did, for he was a man of a singular moral niceness. At any rate he wrote an enthusiastic notice of the opera and an enthusiastic and deserved notice of the impersonatrix of Carmen. And since the Bohemian glass—or the poor remains of the breakages of a quarter of a century—still decorate my side-board, I presume that he accepted the present, I do not really see what else he could have done.

Pressure of other sorts was also not unknown. Thus, there was an opera produced by a foreign Baron who was a distinguished figure in the diplomatic service, and who was very well looked on at Court. In the middle of the performance my father received a command to go into the royal box, where a royal personage informed him that in his august opinion the work was one of genius. My father replied that he was sorry to differ from so distinguished a connoisseur, but that, in his opinion, the music was absolute rubbish—*lauter Klatsch*. The reply was undiplomatic and upon the whole regrettable, but my father had been irritated by the fact that a good deal of Court pressure had already been brought to bear upon him. I believe that there were diplomatic reasons for desiring to flatter the composer of the opera, who was attached to a foreign embassy—the embassy of the nation with whom, for the moment, the diplomatic relations of Great Britain were somewhat strained. So that, without doubt, His Royal Highness was as patriotically in the right as my father was in a musical sense. Eventually the notice of the opera was written by another hand. The performance of this particular opera remains in my mind because, during one of its scenes, which represented the frozen circle of hell, the cotton-wool, which figured as snow on the stage, caught fire and began to burn. An incipient panic took place among the audience, but the orchestra, under a firm composer whose name I have unfortunately forgotten, continued to play, and the flames were extinguished by one of the singers using his cloak. But I still remember being

in the back of the box and seeing in the foreground, silhouetted against the lights of the stage, the figures of my father and of someone else—I think it was William Rossetti—standing up and shouting down into the stalls: 'Sit down, brutes! Sit down, cowards!'

On the other hand, it is not to be imagined that acts of kindness and good-fellowship were rare under this seething mass of passions and of jealousies. Thus at one of the Three Choir Festivals, my father, having had the misfortune to sprain his ankle, was unable to be present in the cathedral. His notice was written for him by the critic of the paper which was most violently opposed to views at all Wagnerian—a gentleman whom, till that moment, my father regarded as his bitterest personal enemy. This critic happened to be staying in the same hotel, and, having heard of the accident, volunteered to write the notice out of sheer good feeling. This gentleman, an extreme *bon vivant* and a man of an excellent and versatile talent, has since told me that he gave himself particular trouble to imitate my father's slightly cumbrous Germanic English and his extreme modernist views. This service was afterward repaid by my father in the following circumstances. It was again one of the Three Choir Festivals—at Worcester, I think, and we were stopping at Malvern—my father and Mr S. going in every day to the cathedral city. Mr S. was either staying with us or in an adjoining house, and on one Wednesday evening, his appetite being sharpened by an unduly protracted performance of *The Messiah*, Mr S. partook so freely of the pleasures of the table that he omitted altogether to write his notice. This fact he remembered just before the closing of the small local telegraph-office, and, although Mr S. was by no means in a condition to write his notice, he was yet sufficiently mellow with wine to be lachrymose and overwhelmed at the idea of losing his post. We rushed off at once to the telegraph-office and did what we could to induce the officials to keep the wires open while the notice was being written. But all inducements failed. My

father hit upon a stratagem at the last moment. At that date it was a rule of the post-office that if the beginning of a long message were handed in before eight o'clock the office must be kept open until its conclusion as long as there was no break in the handing in of slips. My father therefore commanded me to telegraph anything that I liked to the newspaper-office as long as I kept it up while he was writing the notice of *The Messiah*. And the only thing that came into my head at the moment was the church service. The newspaper was therefore astonished to receive a long telegram beginning: '*When the wicked man turneth away from the sin that he has committed*' and continuing through the 'Te Deum' and the 'Nunc Dimittis,' till suddenly it arrived at 'The Three Choirs Festival. Worcester, Wednesday, July 27th, 1887.'

My father represents for me the Just Man! . . . *In memoriam aeternam erit justus* and I do not believe he can ever have faltered before any judgement seat. He was enormous in stature, had a great red beard and rather a high voice. He comes back to me most frequently as standing back on his heels and visibly growing larger and larger. . . . My mother, who was incurably romantic and unreasonable with the unreason that was proper to the femininity of pre-Suffrage days, comes back to me as saying:

'Frank: isn't it just that Fordie should give his rabbit to his brother?' My brother having accidentally stepped on his own rabbit and killed it, my mother considered that I as the eldest should shew an example of magnanimity by giving him mine.

So my father, as large as Rhadamanthus and much more terrible, says: 'No, my dear, it is not *just* that Fordie should give his rabbit to his brother but if you wish it he must obey your orders as a matter of filial piety. . . .' And then the dread, slow: 'Fordie . . . give your . . . rabbit . . . to your . . . brother. . . . *Et plus vite que ça!*' He was fond of throwing in a French phrase.

I don't know who was more dissatisfied with that judge-

ment, I or my mother. But that is no doubt what justice is for.

## MY FATE SETTLED

My father's last words to me were: 'Fordie, whatever you do, never write a book.' Indeed, so little idea had I of meddling with the arts that, although to me a writer was a very wonderful person, I prepared myself very strenuously for the Indian civil service. This was a real grief to my grandfather, and I think he was exceedingly overjoyed when the doctors refused to pass me for that service on the ground that I had an enlarged liver. And when, then, I seriously proposed to go into an office, his wrath became tempestuous.

Tearing off his night-cap—for he happened at the time to be in bed with a bad attack of gout—he flung it to the other end of the room.

'God damn and blast my soul!' he exclaimed. 'Isn't it enough that you escaped providentially from being one kind of a cursed clerk, but you want to go and be another? I tell you, I will turn you straight out of my house if you go in for any kind of commercial life.' So that my fate was settled for me.

## THE PINES, PUTNEY

Well, time went on; my father died; Mr Watts-Dunton became my mother's trustee and my guardian. He also threw his comether over Mr Swinburne and took him to live with him in The Pines, Putney. There they both grew deaf together under the housekeepership of Mr Watts-Dunton's sister, the widow of an attorney who had not made good—in a white, high, widow's cap, white mittens

and a black silk shoulder-cape. Deaf, too.... You may imagine all three deaf people sitting together in the dusk of The Pines waiting for the argand colza-oil lamp to be lighted, when Mr Swinburne and Mrs Mason would play cribbage whilst the poet sipped his glass of Worcester Sauce and Mr Watts-Dunton pored over a crabbed volume of forgotten gipsy lore ... or made pretence so to do.

The Pines, Putney, as its name shews, was no place for the stabling of Pegasus. It was, upon the whole, the most lugubrious London semi-detached villa that it was ever my fate to enter. It was spacious enough, but, built at the time of the 1850–60 craze for Portland cement, its outer surfaces had collected enough soot to give it the aspect of the dwelling of a workhouse-master or chief gaoler. In the sooty garden grew a single fir that, in my time at least, could have gone as a Christmas-tree into the villa's dining-room. In the next garden there had been another, but that had died.

I don't mean to say that the house was poverty-stricken. It was the residence of the highly prosperous family lawyer that Mr Watts-Dunton was, well staffed with servants, the windows and furniture always kept at a high pitch of polish, the cut-steel fire implements always shining.... I imagine the walls must have been covered with brown paper in the proper aesthetic fashion of the advanced of the day and that that drank up the light.... At any rate the rooms of The Pines, Putney, were always dim.... I had occasion to go there pretty frequently ... once a quarter at least when my mother's dividends were due; and on occasion when she had outrun the constable and needed an advance ... or when I myself! ... So it was pretty often.

Then I would be received with an extraordinary pomp of praise by Mr Watts-Dunton. He would address to me studied periods of laudation of my latest published book. ... I had published I think six before I came of age ... and Mr Watts-Dunton addressed me as if I were a public meeting. And Mr Swinburne would add some nervous

phrases to the effect that he intended to read my book as soon as time served.... He would be floating somewhere about in the dimnesses like a shaft of golden light.... But when I came seriously to prefer my request for a cheque and Mr Watts-Dunton had exhausted the praise with which he put me off... then, if I was at all insistent, extraordinary things would happen.... Loud bells would ring all over the establishment. Housemaids would rush in, their cap-strings floating behind, bearing the orange envelopes of telegrams on silver salvers. And Mr Watts-Dunton would start like a ship suddenly struck by a gale, would tear open an envelope and exclaim dramatically:

'Sorry, me dear faller.... Extraordinarily sorry, me dear faller.... Tallegram from Hazlemere. From Lord Tennyson.... Have to go... ah... and correct his proofs at once.... M'm, m'm, m'm.... Desolated to be unable to be further delighted by most int'rustin' conversa...' And he would have disappeared, the dimnesses swallowing him up with improbable velocity....

When it wasn't Lord Tennyson, it would be Browning ... or Coventry Patmore or Lewis Morris....

And you are not to believe that Mr Watts-Dunton was merely a toady. He was an extraordinarily assiduous and skilful family lawyer and adviser as to investments and solvent of brawls and poets' fallings-out.... So that where those poor Pre-Raphaelites would have been without him there is no knowing.... His one novel... *Aylwin*... had the largest sale ever enjoyed by any novel up to that date and for decades after. It was what his friends called bilge, and his innumerable poems seemed to be all devoted to proving that he had once been kissed by a Rommany lal ... a sort of watered-down Isopel Berners.... But what else could the poems and novels of the proprietors of The Pines, Putney, be?... And when reading his poems aloud to Mr Swinburne, he would coyly hold his head on one side as if the better to afford you the view of the spot on the side of his jaw where the gipsy maiden had kissed him. ... And I really believe one must have done so once....

But he did save ever so many of those outrageous poet-painters from the workhouse or the gaol and kept as many more on this side of delirium tremens. . . .

On the less dramatic occasions when Mr Watts-Dunton really produced a cheque I would be invited to stay to lunch. . . . And owing to the increasing deafness of the two friends and of Mrs Mason the meals passed in ever deeper and deeper silence. . . . Mr Swinburne ate, lost in his dreams, with beside his plate, an enormous Persian cat to whom he fed alternate forkfuls of food. Mr Watts-Dunton gobbled his meats with voracity. The cooking was exquisite, the wines quite impeccable—though Mr Swinburne touched none. Mrs Mason addressed inaudible remarks to the maids. . . .

At a given point she would catch the eye of non-existent ladies and rise stiffly. . . . Immediately, with an extremely jerky movement so rapid as to be almost imperceptible, Mr Swinburne would be on his toe-points, positively running to the door, his coat-tails flapping behind him. . . . It was the singular action of an extremely active man. At one moment he was sitting sunk in his chair; at the next he was on the points of his toes and in extraordinarily rapid motion. . . . Mrs Mason would be passing out of the doorway with a rigid inclination of the head to Mr Swinburne, who had opened the door for her; and slowly and meditatively the poet would regain his chair . . . with the litheness of a slow cat . . . and would begin to talk in long, wonderful monologues . . . about the *Bacchae* or the *Birds*.

## BEEF-TEA IN THE NIGHT

I never spoke to Mr Gladstone, but I saw him once extraordinarily close to. I was in a train going north—I should think in 1887. The train stopped at Swindon. Immediately alongside my carriage was another that contained Mr Gladstone. He was sitting reading a memo-

randum with his feet on the cushions of the opposite seat. His face was expressionless, or rather morose. He was quite alone. He was wearing a black woollen cap with ear-flaps tied under his chin. It struck me that anyone could easily have assassinated him if they had wanted to. And plenty did then!

I only once heard Mr Gladstone speak. Then he was in an outrageous temper. He was talking about Egyptian finance and someone—I think Lord Randolph Churchill —ejaculated: 'Remember Gordon!' Mr Gladstone was apparently still sensitive about the accusation that he had allowed Gordon to be murdered at Khartum. He let out a perfect flood of invective as to the unmannerliness of the interjection and menaced his interrupter with a wagging forefinger. His voice was of extreme beauty and of an amazing carrying power. In the Strangers' Gallery you could hear his merely whispered asides—almost his very breathing.

He was said to resemble an eagle. But in his anger he seemed to be very much more like the eagle-owl with all its feathers ruffled up into a shape like the sun. I would have sworn that his eyes were yellow. I wonder if anyone knows what colour his eyes were. Nobody knows that of Napoleon's.

I don't know if you know how many material comforts were lacking in the civilization of those days, I was told by one of the frequent hostesses of Mr. Gladstone that that statesman and his wife always took to bed with them a hot-water bottle filled with beef-tea. They drank the fluid in the night. At six in the morning Mr Gladstone had a grilled chicken leg and an egg beaten up in sherry brought to his bed-side. At eight he ate a great breakfast.

I remember going to a tea-party at the house of the lady who afterwards told me of Mr Gladstone's beef-tea. Mrs Gladstone came in with the tapes of her bodice hanging down on her bustle. No one dared inform her of it. The incident created an extraordinary sensation in London and was widely used as an argument against Home Rule by the

Tories. The argument was this: the Grand Old Man spent so much money in houses of ill fame that, firstly, his wife could not afford a proper lady's maid and, secondly, his behaviour drove Mrs Gladstone mad, so that she ran about with her clothing in disarray. Actually Mrs Gladstone was provided with a perfectly adequate and devoted staff of servants. But as old age came on she disliked standing still whilst her maid adjusted the armour of proof, the whalebones, the hooks and eyes, bustles and jet caparisons that finished the lady's—and the charwoman's—uniform of that day. So whenever she could escape from her maid's hands she would.

The legends that the Tories invented as to Mr Gladstone's incontinence were extraordinary—and they died hard. It is only a few years since a scabrous memoir-writer revived some of them and was suppressed. As a matter of fact, both the Grand Old Man and his wife interested themselves in reclaiming the 'fallen' amongst females—a Victorian pursuit that, if it was as odious as most Victorian moral activities, might still be said to leave its practitioners on the side of the angels.

I remember hearing a dear old lady, Miss Boyd of Penkill, who was not without artistic intelligence and the habit of the great world, definitely assert that the Grand Old Man was in the pay of the Pope and personally officiated at Black Masses. She said she had that on the authority of a Dean of the Anglican Church. I daresay she had.

I had a personal prejudice against Mr Gladstone. He resigned finally on the day when my first book of poems was published. So, although *The Pall Mall Gazette* gave that work a two-column review, it passed unnoticed. The tumult of that awful fall obscured all other events in England!

## TIRED OF PARADES

It must have been in 1891—or possibly in 1892—that I met Bismarck walking all alone in the Popplesdorfer Allée. He was moving very slowly, leaning laboriously upon a cane—in the uniform of his old regiment—the Bonn Cuirassiers. His immense Great Dane, Tiras, the gift of the German nation, followed him, his great head lowered, so that his dewlaps nearly reached his master's heels. The Prince acknowledged my salute with a weary and as if distasteful raising of his heavy lids. It was as if he disliked me intensely. But I daresay it was only that, then, in the period of his fall and loneliness, he disliked the whole world. I remember thinking at the time: 'It is queer he should wear a uniform when now he must be tired of all parades and ceremonies.' But I understand it now. I should like to be wearing a uniform again myself. I suppose I never shall.*

## THE DEATH OF ENGLISH POETRY

Wilde I can never forgive. You may maintain that he had a right to live his own life and, for the sake of sheer vanity, get himself into Reading Gaol. For there was no reason for his going to prison and the last thing that the British authorities wanted to do was to put him there. On the day of his arrest his solicitor received warning that the warrant would not be issued until after 7.00 P.M., the night train for Paris leaving at 6.50 from Charing Cross. I remember still the feeling of anxiety and excitement of the day. Practically everybody in London knew what was agate.

* Written in 1930.

Wilde went to his solicitor—Mr Robert Humphreys; I once had him for my lawyer—about eleven in the morning. Humphreys at once began to beg him to go to Paris. Wilde declared that the authorities dared not touch him. He was too eminent and there were too many others implicated. To that he stuck. He was immovable and would listen to no arguments. There came a dramatic moment in the lawyer's office. Wilde began to lament his wasted life. He uttered a tremendous diatribe about his great talents thrown away, his brilliant genius dragged in the mud, his early and glorious aspirations come to nothing. He became almost epic. Then he covered his face and wept. His whole body was shaken by his sobs. Humphreys was extremely moved. He tried to find consolations.

Wilde took his hands down from his face. He winked at Humphreys and exclaimed triumphantly:

'Got you then, old fellow.' He added: 'Certainly I shall not go to Paris.' He was arrested that evening.

I always intensely disliked Wilde, faintly as a writer and intensely as a human being. No doubt, as a youth he was beautiful, frail and illuminated. But when I knew him he was heavy and dull. I only once heard him utter an epigram. He used to come to my grandfather's with some regularity at one time—every Saturday, I should say. My grandfather was then known as the Grandfather of the Pre-Raphaelites and Wilde passed as a Pre-Raphaelite poet.

He would sit beside the high fire-place and talk very quietly—mostly about public matters: Home Rule for Ireland and the like. My grandfather was a rather down-to-the-ground sort of person, so that Wilde to him talked very much like anyone else and seemed glad to be in a quiet room beside a high fire-place.

Once, at a garden-party at the Bishop of London's, I heard a lady ask him if he were going to the dinner of the O. P. Club that evening. The O. P. Club had some grievance against Wilde. It was a dramatic society or something

of the sort. Dramatic organizations are excitable and mina-
tory when they disliked anybody. It was a dramatic society
that booed and hissed at Henry James when he took his
curtain-call after *Guy Domville*. But really they were
venting their wrath against Sir George Alexander, the
actor-manager who had that evening for the first time
made a charge for programmes. So Wilde would have had
a rough-house at the dinner of the O. P. Club. He there-
fore replied to the lady at the Bishop's party:

'I go to the dinner of the O. P. Club! I should be like
a poor lion in a den of savage Daniels.'

I saw Wilde several times in Paris and he was a truly
miserable spectacle, the butt usually of a posse of merciless
students. He possessed—and it was almost his only pos-
session—a walking-stick of ebony with ivory insertions,
the handle representing an elephant. This he loved very
much because it had been a gift of someone—Lady Mount
Temple, I think. He would be of an evening in one or
another disagreeable *bouge* in Montmartre. The students
would get about him. It was the days of the apaches.
There would be a fellow there called Bibi La Touche or
something of the sort. The students would point him out
to Wilde and declare that Bibi had taken a fancy to his
stick and would murder him on his homeward way if he
did not surrender it. Wilde would cry, the tears pouring
down his great cheeks. But always he surrendered his stick.
The students would return it to his hotel next morning
when he would have forgotten all about it. I, once or per-
haps twice, rescued his stick for him and saw him home.
It would not be agreeable. He did not have a penny and
I had very little more. I would walk him down the miser-
ably lit Montmartrois streets, he completely silent or
muttering things that I did not understand. He walked
always as if his feet hurt him, leaning forward on his
precious cane. When I thought we were near enough to
the Quartier for my resources to let me pay a cab—usually
in the neighbourhood of the Boulevard de la Madeleine—
we would get into one and would at last reach the Rue

Jacob. This happened I think twice, but the memory is one as if of long-continued discomfort. It was humiliating to dislike so much one so unfortunate. But the feeling of dislike for that shabby and incoherent immensity was unavoidable. It had proved so strong that, the locality taking on an aspect of nightmare, I have only once since visited Montmartre at night in, say, thirty-five years and then found it very disagreeable. Of course, the sight of the young people, like starlings, tormenting that immense owl had a great deal to do with my revulsions.

On one occasion—I should think in the Chat Noir—I was with Robert de la Sizéranne and, looking at Wilde who was across the room, he said:

'*Vous voyez cet homme-là. Il péchait par pur snobisme.*'

He meant that, even in his offences against constituted society, Wilde was out to *épater les bourgeois*—to scandalize the middle classes. Sizéranne added: '*Cela le faisait chaque fois vomir!*'

That was pretty generally the French view and, on the face of it, I should say it was just. Sizéranne who was then accounted a very sagacious critic of art, mostly Pre-Raphaelite, moved in French circles where Wilde had once throned it almost as an Emperor.

The rather idle pursuit of *épaté*-ing the bourgeoisie was very much the fashion amongst the *Yellow Book* group who surrounded Wilde. In order to 'touch the Philistine on the raw,' as they called it, the Thompsons, Dowsons, Davidsons, Johnsons and the rest found it necessary to introduce an atmosphere of the Latin Quarter in its lighter —or more dismal side—into London haunts. The Latin Quarter is in fact a very grave, silent and austere region. But it has its Bohemian fringes—and a non-Anglo-Saxon population bred to survive such dissipations as are there to be found. Anglo-Saxons are not so bred. They resemble the populations of Central Africa succumbing before the clothing, gin and creeds of white men. That in the bulk. There are, of course, individuals who survive.

The Bodley Head group did not survive. They suc-

cumbed in London's Soho haunts—to absinthe, to tuber-culosis, to starvation, to reformers or to suicide. But in their day, they were brilliantly before the public, and London was more of a literary centre then than it has ever been before or since.

The book world was then electric. Books were every-where. Accounts of the personal habits of writers filled the daily papers. Minute volumes of poems in limited editions fetched unheard prices at auction. It was good to be a writer in England. And it is to be remembered that, as far as that particular body was concerned, the rewards were earned. They were skilful and earnest writers. They were an immense improvement on their predecessors. They were genuine men of letters.

I was looking last night at the works of Ernest Dowson. They are faint, like drypoint etchings. Their daringnesses are the common coin of to-day. But they have the authentic note. When you read them you have a faint flavour of what was good in those days: the tentativeness of thought, the delicacy, the refinement of point of view. In their day they were international and brilliant. I do not think they will ever appear ignoble.

But all that went with the trial of Wilde.

I hardly came at all in contact with either the Henley or the *Yellow Book* group at that date, though later, I just knew Henley, and Messrs. Whibley, Wedmore and Marriott Watson. I thought then that the others were too harshly brilliant for me. So I was astonished to find in the work of Dowson just now, almost New England delicacies —an as it were Bostonian after-taste. And, if you consider what a considerable part was played by Americans of that type in the art worlds of London and Paris, you will be less astonished to find that flavour.

Those were the days when James and Howell and Harland and Whistler and Sargent and Abbey, not to men-tion lesser lights like G. H. Boughton, more popular ones like Bret Harte or immensely great ones like Mark Twain,

bulked enormously in politely advanced artistic circles in London.

*The Yellow Book* was an American venture and made for those American virtues of delicacy, French technical achievement and New England refinements—thus touching hands with both sides of the Atlantic. And *The Yellow Book* as nearly captured the stronghold of the Established Comfortable that London is, as later—and I hope to show you that—the American movement led by Ezra and called indifferently Vorticism, Futurism, Imagism, so nearly achieved that feat. Then condemnation of Wilde wiped out the one, a large cataclysm the other.

Wilde, then, brought down the *Yellow Book* group and most of the other lyrists of a London that for its year or two had been a nest of singing birds. James and Harland were almost the only survivors. Poets died or fled to other climes, publishers also fled, prosateurs were fished out of the Seine or reformed and the great public said: 'Thank heavens, we need not read any more poetry!'

You may think that an exaggeration. So did I at the time. But, just after the papers had announced the conviction and sentence on Wilde, I was going up the steps of the British Museum. On them I met Dr Garnett, the Keeper of Printed Books, a queer, very tall, lean, untidily bearded Yorkshire figure in its official frock-coat and high hat. I gave him the news. He looked for a moment away over the great yard of the Museum, with its pigeons and lamps and little lions on the railings. Then he said:

'Then that means the death of English poetry for fifty years.'

I can still hear the high tones of my incredulous laughter. At the moment he seemed to me an old obstinate crank, though I knew well how immense was his North Country common sense.

Having a passion for cats, Egyptology, palmistry and astrology, the great scholar could assume some of the aspect of deaf obstinacy that distinguishes cats that do not intend to listen to you. He cast the horoscope of all

his friends and reigning sovereigns; he knew the contents of a hundred thousand books and must have stroked as many thousand 'pussies' pronouncing the 'pus' to rhyme with 'bus.' He was inseparable from his umbrella with which he once beat off two thieves, when at five in the morning he had gone to Covent Garden to buy the household fruit. He was the author of the most delightful volume of whimsico-classical stories that was ever written and the organiser of the compilers of the catalogue of the British Museum Library—an achievement that should render him immortal if his *Twilight of the Gods* fails to do so. He would say to you that the ancient Egyptians were the only really civilized race, for, when fires occurred in their great buildings, they organized environing cordons, not to put out the fires but to see that no cats re-entered their burning homes.

On this occasion he held his top-hatted head obstinately and deftly on one side and repeated, with half-closed eyes:

'That means the death-blow to English poetry. It will not be resuscitated for fifty years.'...

## CITY OF DREADFUL NIGHT

Those were grim enough times for artists—the eighties and early nineties. I don't know that they are any better now. Thus poor James Thomson, writing as B. V., sang of the City of Dreadful Night, and, we are told, drank himself to death. That was the grisly side of it. If you were a poet you lived in deep atmospheric gloom and, to relieve yourself, to see colour, you must sing of Launcelot and Guinevere. If the visions would not come, you must get stimulants to give you them. I remember as a child being present in the drawing-room of a relative just before a dinner at which Tennyson and Browning had been asked to meet a rising poet to whom it was desired to give a

friendly lift. It was the longest and worst quarter of an hour possible. The celebrities fidgeted, did not talk, looked in Olympian manner at their watches. At last they went in to dinner without the young poet. I was too little and too nervous to tell them that half an hour before I had seen the poor fellow lying hopelessly drunk across a whelk-stall in the Euston Road.

One of the grimmest stories that I have heard even of that time and neighbourhood was told me by the late Mr William Sharp. Mr Sharp was himself a poet of the Pre-Raphaelites, though later he wrote as Fiona Macleod, and thus joined the Celtic school of poetry that still flourishes in the person of Mr W. B. Yeats. Mr Sharp had gone to call on Philip Marston, the blind author of 'Songtide,' and of many other poems that in that day were considered to be a certain passport to immortality. Going up the gloomy stairs of a really horrible house near Gower Street Station, he heard proceeding from the blind poet's rooms a loud sound of growling, punctuated with muffled cries for help. He found the poor blind man in the clutches of the poet I have just omitted to name, crushed beneath him and, I think, severely bitten. This poet had an attack of delirium tremens and imagined himself a Bengal tiger. Leaving Marston, he sprang on all fours toward Sharp, but he burst a blood-vessel and collapsed on the floor. Sharp lifted him onto the sofa, took Marston into another room, and then rushed hatless through the streets to the hospital that was round the corner. The surgeon in charge, himself drunk and seeing Sharp covered with blood, insisted on giving him in charge for murder; Sharp, always a delicate man, fainted. The poet was dead of hemorrhage before assistance reached him.

But in gloom and amidst horror they sang on bravely of Launcelot and Guinevere, Merlin and Vivien, ballads of Staffs and Scrips, of music and moonlight. They did not —that is to say—much look at the life that was round them; in amid the glooms they built immaterial pleasure-

houses. They were not brave enough—that, I suppose, is why they are very few of them remembered, and few of them great.

I have, however, very little sense of proportion in this particular matter. There were Philip Bourke Marston, Arthur O'Shaughnessy, 'B. V.,' Theo Marzials, Gordon Hake, Christina Rossetti, Mr Edmund Gosse, Mr Hall Caine, Oliver Madox Brown, Mr Watts-Dunton, Mr Swinburne, D. G. Rossetti, Robert Browning! ...

## THE GLOOM OF LONDON

I fancy the physical gloom of London adds to the heaviness of my memory of those days. A city whose streets are illuminated only by the flicker of rare street-lamps seems almost darker than one not lit at all. And the corners of rooms are always filled with shadows when the sole illuminant is a dim oil-lamp or a bluish gas-flame. And in London it was always winter. I remember, at any rate, no spring.

Above the darkness brooded the Hard Times. I am talking now of the early nineties. It is difficult to think how people lived then. In cold, in darkness, lacking sufficient clothes or sufficient food. With the aid of gin perhaps, or beer when you could cadge a pint. Charles Booth in his *Life and Labour of the Poor in London* states that 90 per cent of the population of London in those days depended for its *menus plaisirs*—its glimpses of light, of pleasure, its beanfeasts, its pints at the pubs—on windfalls. A working-man got the price of a pint of beer for dexterously holding a lady's skirts off the wheel as she stepped out of a carriage. He would get as much for hailing a cab on a wet night. A charwoman got an old dress given her and sold it in a rag-and-bone shop for the price of a quartern of gin. Cooks had their perquisites—their 'perks.' Old women with 'puffity pockets' beneath their

skirts slunk up and down area railings. When they went up, the pockets would contain pounds of dripping: mutton-fat, half plum-cakes, remains of joints of beef. With the price of them the cook would get a new hat and some tobacco for her father in the workhouse. You lived in slums in Seven Dials, Whitechapel, Notting Dale. You burned the stair-rails and banisters, the door-jambs, the window-frames for fuel. The rest of the world was no better. In Paris half the population was insufficiently fed; on sunny days the most horrible, half-nude creatures sunned themselves on the benches of the Champs-Elysées. In Berlin the greater part of the population never thought of tasting meat. In St Petersburg the condition of the poor would not bear thinking of. When you did witness it, you went mad or divested yourself of all your goods. Kropotkin had done that and was only one of scores of Princes and great land-owners. 'The poor,' the middle-class householder said, 'are always with us. These are the words of Jesus Christ.' So he put on several mufflers, buried his purse in an inner pocket and buttoned up his overcoat to the chin, the better to avoid the temptation to give a starving woman a ha'penny. I remember taking the young daughter of my father's most intimate friend, who was Queen Victoria's Master of Music, on the River Blythe in a canoe. I talked to her about the conditions of the poor. Next day her mother Lady Cusins said to me:

'Fordie, you are a dear boy. Sir George and I like you very much. But I must ask you not to talk to dear Beatrice ... about Things!' *Punch* itself was once almost suppressed. It printed a drawing of Charles Read's, showing two miserable women of the 'Unfortunate Class' soaked by rain and shivering under one of the Adelphi arches. One of them says to the other: 'Dearie. . . . 'Ow long 'ave *you* been gay!' 'Gay,' of course, signified 'unfortunate.' The consternation in Victorian London was terrific. *Punch* had spoken about Things. It never has again.

The natural corollary of these pressures was ... Anar-

chism, Fabianism, dynamitings, Nihilism. I saw a good deal of the inner workings of these.

## MONSTROUS SOLEMN FUN

I don't know where the crowds came from that supported us as Anarchists, but I have seldom seen a crowd so great as that which attended the funeral of the poor idiot who blew himself to pieces in the attempt on Greenwich Observatory. This was, of course, an attempt fomented by the police agents of a foreign state with a view to forcing the hand of the British Government. The unfortunate idiot was talked by these *agents provocateurs* into taking a bomb to Greenwich Park, where the bomb exploded in his pocket and blew him into many small fragments. The idea of the Government in question was that this would force the hand of the British Government so that they would arrest wholesale every Anarchist in Great Britain. Of course, the British Government did nothing of the sort, and the crowd in Tottenham Court Road which attended the funeral of the small remains of the victim was, as I have said, one of the largest that I have ever seen. Who were they all? Where did they all come from? Whither have they all disappeared? I am sure I don't know, just as I am pretty certain that, in all those thousands who filled Tottenham Court Road, there was not one who was more capable than myself of beginning to think of throwing a bomb. I suppose it was the spirit of romance, of youth, perhaps of sheer tomfoolery, perhaps of the spirit of adventure, which is no longer very easy for men to find in our world of grey and teeming cities. I couldn't be Dick Harkaway with a Winchester rifle, so I took it out in monstrous solemn fun, of the philosophic Anarchist kind, and I was probably one of twenty thousand. My companion upon this occasion was Comrade P., who, until quite lately, might be observed in the neighbourhood of

the British Museum—a man with an immensely long beard, with immensely long hair, bare-headed, bare-legged, in short running-drawers, and a boatman's jersey, that left bare his arms and chest. Comrade P. was a medical man of great skill, an eminently philosophic Anarchist. He was so advanced in his ideas that he dispensed with animal food, dispensed with alcohol and intensely desired to dispense with all clothing. This brought him many times into collision with the police, and as many times he was sent to prison for causing a crowd to assemble in Hyde Park, where he would appear to all intents and purposes in a state of nature. He lived, however, entirely upon crushed nuts. Prison diet, which appeared to him sinfully luxurious, inevitably upset his digestion. They would place him in the infirmary and would feed him on boiled chicken, jellies, beef-tea and caviare, and all the while he would cry out for nuts, and grow worse and worse, the prison doctors regularly informing him that nuts were poison. At last Comrade P. would be upon the point of death, and then they would give him nuts. P. would immediately recover, usually about the time that his sentence had expired. Then, upon the Sunday, he would once more appear like a Greek athlete running through Hyde Park. A most learned and gentle person, most entertaining and the best of company, this was still the passion of his life. The books in the British Museum were almost a necessity of his existence, yet he would walk into the reading-room attired only in a blanket, which he would hand to the cloak-room attendant, asking for a check in return. Eventually his reader's ticket was withdrawn, though with reluctance on the part of the authorities, for he was a fine scholar, and they very humane men. Some time after this Comrade P. proposed to me that I should accompany him on the top of a bus. His idea was that he would be attired in a long ulster; this he would take off and hand to me, whereupon I was to get down and leave him in this secure position. My courage was insufficient—the united courages of all Comrade P.'s friends were insufficient to

let them aid him in giving thus early a demonstration of what nowadays we call the Simple Life, and Comrade P. had to sacrifice his overcoat. He threw it, that is to say, from the top of the bus, and, with his hair and beard streaming over his uncovered frame, defied alike the elements and the police. The driver took the bus, Comrade P. and all, into an empty stable, where they locked him up until the police arrived with a stretcher from Bow Street. At last the magistrate before whom Comrade P. habitually appeared grew tired of sentencing him. Comrade P. was, moreover, so evidently an educated and high-minded man that the stipendiary perhaps was touched by his steadfastness. At all events, he invited P. to dinner—I don't know what clothes P. wore upon this occasion. Over this friendly meal he extracted from P. a promise that he would wear the costume of running-drawers, an oarsman's jersey and sandals which I have already described, and which the magistrate himself designed. Nothing would have persuaded P. to give this promise had not the magistrate promised in return to get for P. the reader's ticket at the British Museum which he had forfeited. And so, for many years, in this statutory attire P., growing greyer and greyer, might be seen walking about the streets of Bloomsbury. Some years afterward, when I occupied a cottage in the country, P. wrote and asked to be permitted to live in my garden in a state of nature. But, dreading the opinions of my country neighbours, I refused, and that was the last I heard of him.

## THE TRIUMPH OF THE BOURGEOISIE

My grandfather, a romantic old gentleman of the Tory persuasion by predisposition, was accustomed to express himself as being advanced in the extreme in his ideas. Such was his pleasant fancy that I am quite certain he would have sported a red tie had it not clashed with the

blue linen shirts that he habitually wore. And, similarly, my Aunt Rossetti, to whom my infant thoughts were so frequently entrusted—this energetic and romantic lady was of such advanced ideas that I have heard her regret that she was not born early enough to be able to wet her handerkerchief in the blood of the aristocrats during the French Reign of Terror. Nay, more, during that splendid youth of the world in the eighties and nineties, the words 'the Social Revolution' were forever on our lips. We spoke of it as if it were always just around the corner, like the three-horse omnibus which used to run from Portland Place to Charing Cross Station—a bulky conveyance which we used to regard with longing eyes as being eminently fitted, if it were upset, to form the very breastwork of a barricade—in these young, splendid and stern days my cousins, the Rossettis, aided, if not pushed to it, by my energetic, romantic aunt, founded that celebrated Anarchist organ known as *The Torch*. But, though my grandfather hankered after wearing a red tie, said that all lords were damned flunkeys, that all Her Majesty's judges were venial scoundrels, all police magistrates worse than Judas Iscariot and all policemen worse even than Royal Academicians—it would never, no, it would never have entered his head to turn one of his frescoes in the Town Hall, Manchester, into a medium for the propaganda of the Social Revolution. He hated the bourgeoisie with a proper hatred, but it was the traditional hatred of the French artist. The bourgeoisie returned his hatred to more purpose, for, just before his death, the Town Council of Manchester, with the Lord Mayor at its head, sitting in private, put forward a resolution that his frescoes in the Town Hall should be whitewashed out and their places taken by advertisements of the wares of the aldermen and the councillors. Thus perished Ford Madox Brown—for this resolution, which was forwarded to him, gave him his fatal attack of apoplexy. The bourgeoisie had triumphed.*

* This resolution was never carried out, and the triumph of the bourgeoisie short lived.

## ROSSETTI'S INVERNESS CAPE

Upon Rossetti's death his Inverness, which was made in the year 1869, descended to my grandfather. Upon my grandfather's death it descended to me, it being then twenty-three years old. I wore it with feelings of immense pride, as if it had been—and indeed, was it not?—the mantle of a prophet. And such approbation did it meet in my young friends of that date that this identical garment was copied seven times, and each time for the use of a gentleman whose works when Booksellers' Row still existed might ordinarily be found in the twopenny box. So this garment spread the true tradition, and, indeed, it was imperishable and indestructible, though what has become of it by now I do not know. I wore it for several years until it must have been aged probably thirty, when, happening to wear it during a visit to my tailor's and telling that gentleman its romantic history, I was distressed to hear him remark, looking over his pince-nez:

'Time the moths had it!'

This shed such a slight upon the garment from the point of view of tailors that I never wore it again. It fell, I am afraid, into the hands of a family with little respect for relics of the great, and I am fairly certain that I observed its capacious folds in the mists of an early morning upon Romney Marsh some months ago, enveloping the limbs of an elderly and poaching scoundrel called Slingsby.

## MY MUSIC MASTER

I used to have violin lessons from the queer, tragic Borschitzky whose dismal adventure caused Euston Square

to be re-christened. He came home late at night and found his landlady murdered in the kitchen. Being nearly blind he fell over the body, got himself covered with blood and as a foreigner and a musician was at once arrested by the intelligent police. He was of course acquitted but the trial caused so much sensation as the 'Euston Square murder' that the respectable inhabitants petitioned to have the name of the square changed and it became Endsleigh Gardens.

Poor Borschitzky was a small, bald man with an immense nose who wore his greyish hair brushed stiffly forward into peaks, and his Gladstone collars came forward into peaks equally stiff. He was usually dressed in an immensely long frock-coat that nearly hid his tiny legs and enormous feet. He spoke the most extravagantly pidgin English I have ever imagined and told the longest and most extraordinary stories.

His stories went like this:

'Zair voss a Gris-chun met a Chew. 'E sez to 'im: "You uckly Chew I haf ad a mos' 'orible tream. It voss a mos' 'orible tream. I tream I co to dhe Chewish Evven an it voss a mos' 'orible place. Ze spidoons voss all filzy an ze daples coffred viz creese and dher voss no sand on de floor and de praziers voss dhick wiz rust. O it voss a mos' 'orible place and it voss fooll fooll fooll of 'orible uckly Chews spiddin on ze floor and shmoking; shmoking filthy filthy paipes."

'"Dad voss vairy curious," sez ze Chew. "I allso haf a tream. I tream I co to dhe Gris-chun Evven. O, and it voss a mos' loffly place. De spidoons voss of prass zat shone laike colld and dhe sand on der floor laike silber. Ond de daples voss viter ass a snotrift ond de praziers voss silber ond de dobacco poxes oll retty do be smoaked: O it voss a mos' loffly place. Loffly; loffly! ontly . . . zer vos nowun in it!"'

Towards the end of his life great troubles fell on poor Borschitzky. His mainstay had for years been the preparatory school to which I was sent. All his other pupils fell

away; no orchestra would any longer employ him or play his compositions. Then his old friends, the owners of the school, died. They had supported him for years in spite of his peculiarities. The new owners of the school dismissed him. Then he had nothing and was perhaps seventy-two. He packed up his never-played compositions in several bundles and took them to the British Museum Library. Doctor Garnett told him kindly that the Museum only accepted the compositions of the dead. He went to the Post-Office at the corner of Endsleigh Gardens, mailed the parcel to the Museum and then back to his room. He tidied it very thoroughly and destroyed a number of papers. Then he went out and by the railings of the Square before his windows he cut his throat. If he had done it indoors it would have caused his landlady a great deal of trouble and have made a horrid mess for her to clean up.

But still, when in Continental cathedrals I hear the boom of the serpent and the sharp tap of the cantor as he starts the choir in its plain-song, I see the form of poor Borschitzky with his bow held over his beloved fiddle and the school choir with its mouths all open before him. He taps magisterially three times with his bow, his side-locks stick forward, his coat-tails hanging down to his enormous boots. 'Van! Doo! Dree ... Pom-Pom,' he shouts and off we all go on his rendering of the words that accompany the Ninth Symphony. God send him an old leather cushion stuffed with straw for his hard chair in his Chewish Evven ... and send to all old, worn-out artists to be as considerate in their final distress.

## TRADITION AMPLY CARRIED ON

At the last public school which I attended—for my attendances at schools were varied and singular, according as my father ruined himself with starting new periodicals

or happened to be flush of money on account of new legacies—at my last public school I was permitted to withdraw myself every afternoon to attend concerts. This brought down upon me the jeers of one particular German-master who kept order in the afternoons, and upon one occasion he set for translation the sentence:

'Whilst I was idling away my time at a concert the rest of my class-mates were diligently engaged in the study of the German language.'

Proceeding mechanically with the translation—for I paid no particular attention to Mr P., because my father, in his reasonable tones, had always taught me that schoolmasters were men of inferior intelligence to whom personally we should pay little attention, though the rules for which they stood must be exactly observed—I had got as far as '*Indem ich faulenzte . . .*' when it suddenly occurred to me that Mr P., in setting this sentence to the class, was aiming a direct insult not only at myself, but at Beethoven, Bach, Mozart, Wagner and Robert Franz. An extraordinary and now inexplicable fury overcame me. At all my schools I was always the good boy of my respective classes, but on this occasion I rose in my seat, propelled by an irresistible force, and I addressed Mr P. with words the most insulting and the most contemptuous. I pointed out that music was the most divine of all arts: that German was a language fit only for horses; that German literature contained nothing that any sensible person could want to read except the works of Schopenhauer, who was an Anglomaniac, and in any case was much better read in an English translation; I pointed out that Victor Hugo has said that to alter the lowest type of inanities, '*il faut être stupide comme un maître d'école qui n'est bon à rien que pour planter des choux.*' I can still feel the extraordinary indignation that filled me, though I have to make an effort of the imagination to understand why I was so excited; I can still feel the way the breath poured through my distended nostrils. With, I suppose, some idea of respect for discipline, I had carefully spoken in German, which none

of my class-mates understood. My harangue was suddenly ended by Mr P.'s throwing his large inkpot at me; it struck me upon the shoulder and ruined my second-best coat and waist-coat.

I thought really no more of the incident. Mr P. was an excellent man, with a red face, a bald head, golden side-whiskers and an apoplectic build of body. Endowed by nature with a temper more than volcanic, it was not unusual for him to throw an inkpot at a boy who made an exasperating mistranslation, but he had never before hit anybody; so that meeting him afterward in the corridors I apologised profusely to him. He apologised almost more profusely to me, and we walked home together, our routes from school being exactly similar. I had the greatest difficulty in preventing his buying me a new suit of clothes, while with a gentle reproachfulness he reproved me for having uttered blasphemies against the language of Goethe, Schiller, Lessing and Jean Paul Richter. It was then toward the end of the term, and shortly afterward the headmaster sent for me and informed me that I had better not return to the school. He said—and it was certainly the case—that it was one of the founder's rules that no boy engaged in business could be permitted to remain. This rule was intended to guard against gambling and petty huckstering among the boys. But Mr K. said that he understood I had lately published a book and had received for it not only publicity but payment, the payment being against the rules of the school, and the publicity calculated to detract from a strict spirit of discipline. Mr K. was exceedingly nice and sympathetic, and he remarked that in his day my uncle Oliver Madox Brown had had the reputation of being the laziest boy at that establishment, while I had amply carried on that splendid tradition.

## MY OLDEST LITERARY RECOLLECTION

Thinking and walking up and down in the tall room of a friend in Greenwich Village I looked at a bookshelf, then took out a dullish-backed book at random. At the bottom of a page were the words:

'So you see, darling, there is really no fear, because, as long as I know you care for me and I care for you, nothing can touch me.'

I had a singular emotion. I was eighteen when I first read those words. My train was running into Rye Station and I had knocked out the ashes of my first pipe of shag tobacco. Shag was the very cheapest, blackest and strongest of tobaccos in England of those days. I was therefore economizing. My first book had just been published. I was going courting. My book had earned ten pounds. I desired to be a subaltern in H.B.M.'s Army. The story was Mr Kipling's 'Only a Subaltern.' The next station would be Winchelsea, where I was to descend. I had given nine of the ten pounds to my mother. If I was to marry and become a subaltern, I must needs smoke shag. And in a short clay pipe, to give the fullest effect to retrenchment! Briars were then eighteenpence, short clays two for a penny.

That is my oldest literary recollection.

It is one of my most vivid. More plainly than the long curtains of the room in which I am writing, I see now the browning bowl of my pipe, the singularly fine grey ashes, the bright placards as the train runs into the old-fashioned station and the roughness of the paper on which there appeared the words——

*So you see, darling, there is really no fear*——

I suppose they are words that we all write one day or another. Perhaps they are the best we ever write.

The fascicle of Kipling stories had a blue-grey paper

cover that shewed in black a fierce, whiskered and turbaned *syce* of the Indian Army. I suppose he was a *syce*, for he so comes back to me. At any rate, that cover and that Mohammedan were the most familiar of objects in English homes of that day. You have no idea how exciting it was in those days to be eighteen and to be meditating, writing for the first time *there is really no fear.* . . .

## REGRETS

I saw Samuel Butler bearing down on us.* I disliked Samuel Butler more than anyone I knew. He was intolerant and extraordinarily rude in conversation—particularly to old ladies and young persons. He had perhaps cause to be, for he was conscious of great gifts and of being altogether neglected. In those days he was almost unknown. *Erewhon* was nearly forgotten, *The Way of All Flesh* unpublished and not even fully written. Otherwise he was unfavourably known as having pirated the ideas of Darwin and as having behaved with extraordinary rudeness to that great and aged scientist. It struck me that, as he was bearing down on us, he had the air of a pirate. His complexion was fresh, his hair and torpedo beard of silver grey; he kept his hands usually in his coat-pocket. His coat was a square blue reefer; his red necktie was confined in a gold scarf ring. It is one of the regrets of my life that I made nothing at all of two of the most remarkable men I ever met casually and fairly frequently. Butler was too arrogant, Synge too modest. I saw Synge rather often when he was a journalist in Paris. He said very little and seemed to be merely another, florid, tuberculous Irishman. Yet I suppose that *The Way of All Flesh* and *The Playboy of the Western World* are the two great milestones on the

* At a tea party in Dr Richard Garnett's rooms in the British Museum.

road of purely English letters between *Gulliver's Travels* and Joyce's *Ulysses*.

## A PHILOSOPHER'S SILENCE

The late Mr Herbert Spencer once sat at table next to a connection of my own for three consecutive days. He sat in deep silence. Upon the fourth day he took from his ears two little pads of cotton-wool. He exhibited them to the lady and remarking, 'I stop my ears with these when I perceive there is no one at the table likely to afford rational conversation,' he put them back again.

## A MR HARDY

I was keenly aware of a Mr Hardy who was a kind, small man, with a thin beard, in the background of London tea-parties ... and in the background of my mind. ... I remember very distinctly the tea-party at which I was introduced to him by Mrs Lynn Lynton with her paralys-ing, pebble-blue eyes, behind gleaming spectacles. Mrs Lynn Lynton, also a novelist, was a Bad Woman, my dear. One of the Shrieking Sisterhood! And I could never have her glance bent on me from behind those glasses without being terrified at the fear that she might shriek ... or be Bad. I think it was Rhoda Broughton who first scandalized London by giving her heroine a Latchkey. But Mrs Lynn Lynton had done something as unspeak-ably wicked. ... And I was a terribly proper young man.

So, out of a sort of cloud of almost infantile paralysis— I must have been eighteen to the day—I found myself telling a very very kind, small, ageless, soft-voiced gentle-man with a beard, the name of my first book, which had been published a week before. And he put his head on one

side and uttered, as if he were listening to himself, the syllables: 'Ow ... Ow. ...'

I was petrified with horror ... not because I thought he had gone mad or was being rude to me, but because he seemed to doom my book to irremediable failure. ...

I do not believe I have ever mentioned the name of one of my own books in my own print ... at least I hope I have been too much of a little gentleman ever to have done so. But I do not see how I can here avoid mentioning that my first book was called *The Brown Owl* and that it was only a fairy-tale. ... I will add that the publisher—for whom Mr Edward Garnett was literary adviser—paid me ten pounds for it and that it sold many thousands more copies than any other book I ever wrote ... and keeps on selling to this day.

And on that day I had not got over the queer feeling of having had a book published. ... I hadn't wanted to have a book published. I hadn't tried to get it published. My grandfather had, as it were, ordered Mr Garnett to get it published. ... I can to this day hear my grandfather's voice saying to Mr Garnett, who was sitting to him on a model's throne:

'Fordie has written a book, too. ... Go and get your book, Fordie!' ... and the manuscript at the end of Mr Garnett's very thin wrist disappearing into his capacious pocket. ... And my mother let me have ten shillings of the money paid by Mr Garnett's employer. ... And that had been all I had got of authorship. ... So that I thought authorship was on the whole a mug's game and concealed as well as I could from my young associates the fact that I was an Author. I should have told you that that was my attitude and should have believed it. My ambition in those days was to be an Army Officer!

And then suddenly, in Mrs Lynn Lynton's dim, wicked drawing-room, in face of this kind, bearded gentleman, I was filled with consternation and grief. Because it was plain that he considered that the vowel sounds of the title of my book were ugly and that, I supposed, would mean

that the book could not succeed. So I made the discovery that I—but tremendously!—wished that the book should succeed ... even though I knew that if the book should succeed it would for ever damn my chances as one of Her Majesty's officers. ...

And I could feel Mr Hardy feeling the consternation and grief that had come up in me, because he suddenly said in a voice that was certainly meant to be consolatory:

'But of course you meant to be onomatopoeic. Ow—ow—representing the lamenting voices of owls. ... Like the repeated double O's of the opening of the Second Book of *The Aeneid*. ...'

On that distant day in Mrs Lynton's drawing-room, I was struck as dumb as a stuck pig. I could not get out a word whilst he went on talking cheerfully. He told me some anecdotes of the brown owl and then remarked that it might perhaps have been better if, supposing I had wanted to represent in my title the cry of the brown owl, instead of two 'ow' sounds I could have found two 'oo's.' ... And he reflected and tried over the sound of 'the brooding coots' and 'the muted lutes.'. ...

And then he said, as if miraculously to my easement:

'But of course you're quite right. ... One shouldn't talk of one's books at tea-parties. ... Drop in at Max Gate when you are passing and we'll talk about it all in peace. ...'

Marvellously kind ... and leaving me still a new emotional qualm of horror. ... Yes, I was horrified ... because I had let that kind gentleman go away thinking that my book was about birds ... whereas it was about Princesses and Princes and magicians and such twaddle. ... I had written it to amuse my sister Juliet. ... So I ran home and wrote him a long letter telling him that the book was not about birds and begging his pardon in several distinct ways. ...

Then a storm burst on the British Museum. The young Garnetts went about with appalled, amused, incredulous or delighted expressions, according as the particular young

Garnett was a practicing Anglican, an Agnostic or a Nihilist. . . . It began to be whispered by them that Mrs Hardy, a Dean's daughter, had taken a step. . . . She had been *agonised* . . . she hadn't been able to *stand* it. . . . The reception of *Tess* had been too *horrible* . . . for a Dean's daughter. . . . All the Deans in Christendom had been driven to consternation about *Tess*. They had all arisen and menaced Max Gate with their croziers. (I know that Deans do not wear croziers. But that was the effect the young Garnetts had produced.)

It came out at last. . . . Mrs Hardy had been calling on Dr Garnett as the Dean of Letters of the British Isles and Museum to beg, implore, command, threaten, anathematize her husband until he should be persuaded or coerced into burning the manuscript of his new novel— which was *Jude*. She had written letters; she had called. She had wept; like Niobe she had let down her blond hair. . . . The Agnostic and Nihilist young Garnetts rejoiced, the Anglicans were distraught. Doctor Garnett had obdurately refused. . . . I don't believe I cared one way or the other. I didn't like the Church of England. On the other hand I didn't want any lady or a multitude of Deans to be distressed. . . .

A long time after—six months, I dare say—I had my answer from Mr Hardy. It seemed to be part of his immense kindness that, though he should have so long delayed the answer, nevertheless he should have answered. The tendency of ordinary men, if they have not answered a letter for a long time, is to tear it up and throw it into the waste-paper basket. I imagined him to have waited until the tremendous stir and racket over *Jude the Obscure* should have died away, but never to have put out of his mind altogether the letters that his kindness told him he ought eventually to write.

Mr Hardy told me again to drop in on him any time I might be in the neighbourhood of Dorchester. He told me not to be ashamed of writing fairy-tales. Some of the greatest literature in the world was enshrined in that form.

When I came to Dorchester he would perhaps be able to give me points out of his store of Wessex folklore. So I staged a walking-tour that should take me by Weymouth and Wooler and the Lyme Regis of Jane Austen and Charmouth ... and of course Dorchester, for I could not bring myself to take the straight train down to that city. I had to obey his orders and 'drop in' casually whilst strolling about that country of chalk downs and the sea.

Alas, when I got to Max Gate, Mr Hardy was away for the day. He had gone, I think, to witness a parade of the militia at Weymouth which I had just left. So, instead of listening to Mr Hardy's Wessex folklore, I listened nervously whilst Mrs Hardy in her Junonian blondness of a Dean's daughter read me her own poems over a perfectly appointed tea-table in a room without roses peeping in at the windows but properly bechintzed.

I don't know whether it was really a militia parade that he had gone to Weymouth to witness any more than Mrs Hardy was really a Dean's daughter. That was merely the Garnettian slant on the Hardy household. Those lively young people, whose father was really very intimate with the novelist, had projected such an image of that household that I had gone there expecting to find in a low inner room of a long white farmhouse with monthly roses peeping in at the window, the kind elderly gentleman who had held his head on one side and said: 'Ow ... ow.'... And in another room the Dean's daughter would be burning the manuscript of *Jude the Obscure*.

It was all naturally nothing of the sort. Max Gate was not an old, long, thatched farmhouse; it was quite new, of brick, with, as it were, high shoulders. Not a single rose grew on it at that date. And the Dean's daughter was not a Dean's daughter but an Archdeacon's Niece ... the Archdeacon of London's niece. And she was not burning *Jude the Obscure*, but read me her own innocuous poems. And the kind bearded gentleman whose beardedness made him resemble any one of the elder statesmen of the day—Sir Charles Dilke, or Lord Salisbury, or the Prince of

Wales of those days, or Mr Henry James ... that kind bearded gentleman was not there....

And immediately on hearing that he was out, my mind had jumped to the conclusion that he was witnessing a review of the militia ... I suppose because I knew that one of his stories was called *The Trumpet Major*....

And then nothing more for years. *Jude the Obscure* came out amidst a terrific pother. But the pother took place in circles remote from my own ... circles where they still fought bloodily about the Real Presence, the Virgin Birth or whether the human race had in the beginning been blessed with prehensile tails ... none of which seemed to be any affair of mine.... And the Literary Great of the country sat about each on their little hill ... Mr Meredith at Box Hill, Mr Kipling at Burwash, Mr Hardy at Max Gate, and the William Blacks and James Payns and Marion Crawfords and Lord Tennysons each on his little monticule.... Official Literature in short drowsed on on its profitable way and we, *les jeunes*, had other fish to fry.

# THE KING OF HEARTS

## *Ford Madox Brown*

MADOX BROWN has been dead for twenty years now, or getting on for that.* I would not say that the happiest days of my life were those that I spent in his studio, for I have spent in my life days as happy since then; but I will say that Madox Brown was the finest man I ever knew. He had his irascibilities, his fits of passion when, tossing his white head, his mane of hair would fly all over his face, and when he would blaspheme impressively after the manner of our great-grandfathers. And in these fits of

* Written in 1910.

temper he would frequently say the most unjust things. But I think that he was never either unjust or ungenerous in cold blood, and I am quite sure that envy had no part at all in his nature. Like Rossetti and like William Morris, in his very rages he was nearest to generosities. He would rage over an injustice to someone else to the point of being bitterly unjust to the oppressor. I do not think that I would care to live my life over again—I have had days that I would not again face for a good deal—but I would give very much of what I possess to be able, having still such causes for satisfaction as I now have in life, to be able to live once more some of those old evenings in the studio.

The lights would be lit, the fire would glow between the red tiles; my grandfather would sit with his glass of weak whisky and water in his hand, and would talk for hours. He had anecdotes more lavish and more picturesque than any man I ever knew. He would talk of Beau Brummell, who had been British Consul at Calais when Madox Brown was born there; of Paxton, who built the Crystal Palace, and of the mysterious Duke of Portland, who lived underground, but who, meeting Madox Brown in Baker Street outside Druces', and hearing that Madox Brown suffered from gout, presented him with a large quantity of colchicum grown at Welbeck. . . .

Well, I would sit there on the other side of the rustling fire, listening, and he would revive the splendid ghosts of Pre-Raphaelites, going back to Cornelius and Overbeck and to Baron Leys and Baron Wappers, who taught him first to paint in the romantic, grand manner. He would talk on. Then Mr William Rossetti would come in from next door but one, and they would begin to talk of Shelley and Browning and Mazzini and Napoleon III, and Mr Rossetti, sitting in front of the fire, would sink his head nearer and nearer to the flames. His right leg would be crossed over his left knee, and, as his head went down, so, of necessity, his right foot would come up and out. It would approach nearer and nearer to the fire-irons which

stood at the end of the fender. The tranquil talk would continue. Presently the foot would touch the fire-irons and down they would go into the fender with a tremendous clatter of iron. Madox Brown, half-dozing in the firelight, would start and spill some of his whisky. I would replace the fire-irons in their stand.

The talk would continue, Mr Rossetti beginning again to sink his head toward the fire, and explaining that, as he was not only bald but an Italian, he liked to have his head warmed. Presently, bang! would go the fire-irons again. Madox Brown would lose some more whisky and would exclaim:

'Really, William!'

Mr Rossetti would say:

'I am very sorry, Brown.'

I would replace the fire-irons again, and the talk would continue. And then for the third time the fire-irons would go down. Madox Brown would hastily drink what little whisky remained to him, and, jumping to his feet, would shout:

'God damn and blast you, William! Can't you be more careful?'

To which his son-in-law, always the most utterly calm of men, would reply:

'Really, Brown, your emotion appears to be excessive. If Fordie would leave the fire-irons lying in the fender there would be no occasion for them to fall.'

The walls were covered with gilded leather; all the doors were painted dark green; the room was very long, and partly filled by the great picture that was never to be finished, and, all in shadow, in the distant corner was the table covered with bits of string, curtain-knobs, horseshoes, and odds and ends of iron and wood.

I remember my grandfather laying down a rule of life for me. He said:

'Fordie, never refuse to help a lame dog over a stile. Never lend money; always give it. When you give money to a man that is down, tell him that it is to help him to

get up, tell him that when he is up he should pass on the money you have given him to any other poor devil that is down. Beggar yourself rather than refuse assistance to any one whose genius you think shows promise of being greater than your own.'

This is a good rule of life. I wish I could have lived up to it. The Pre-Raphaelites, as I have tried to make plain, quarrelled outrageously, as you might put it, about their boots or their washing. But these quarrels as a rule were easily made up; they hardly ever quarrelled about money, and they never, at their blackest moments, blackened the fame of each other as artists. One considerable convulsion did threaten to break up Pre-Raphaelite society. This was caused by the dissolution of the firm of Morris, Marshall, Faulkner & Company. Originally in this firm there were seven members, all either practising or aspiring artists. The best known were William Morris, Rossetti, Burne-Jones and Madox Brown. The 'Firm' was founded originally by these men as a sort of co-operative venture. Each of the artists supplied designs, which originally were paid for in furniture, glass or fabrics. Each of the seven partners found a certain proportion of the capital—about one hundred pounds apiece, I think. As time went on they added more capital in varying proportions, Morris supplying by far the greater part. Gradually the 'Firm' became an important undertaking. It supplied much furniture to the general public; it supplied a great number of stained-glass windows to innumerable churches and cathedrals. It may be said to have revolutionized at once the aspect of our homes and the appearance of most of our places of worship. But, while the original partnership existed, the finances of the 'Firm' were always in a shaky condition.

The day came when Morris perceived that the only way to save himself from ruin was to get rid of the other partners of the 'Firm,' to take possession of it altogether, and to put it in a sound and normal financial position. Now-a-days I take it there would be the makings of a splendid and instructive lawsuit. But Morris & Company

passed into the hands of William Morris; Rossetti, Madox Brown and the rest were displaced, and there was practically no outcry at all. This was very largely due to the self-sacrificing labours of Mr Watts-Dunton—surely the best of friends recorded in histories or memoirs. How he did it I cannot begin to imagine; but he must have spent many sleepless nights and have passed many long days in talking to these formidable and hot-blooded partners. Of course he had to aid him the fact that each of these artists cared more for their work than for money, and more for the decencies of life and good-fellowship than for the state of their pass-books.

A certain amount of coldness subsisted for some time between all the parties, and indeed I have no doubt that they all said the most outrageous things against each other. Some of them, indeed, I have heard, but in the end that gracious and charming person, Lady Burne-Jones, succeeded in bringing all the parties together again. William Morris sent Madox Brown copies of all the books he had written during the estrangement, Madox Brown sent William Morris a tortoise-shell box containing a dozen very brilliant bandana pocket-handkerchiefs, and joined the Kelmscott House Socialist League. Indeed, one of the prettiest things I can remember was having seen Madox Brown sitting in the central aisle of the little shed attached to Morris's house at Hammersmith. Both of them were white-headed then; my grandfather's hair was parted in the middle and fell, long and extremely thick, over each of his ears. It may interest those whose hair concerns them to know that every morning of his life he washed his head in cold water and with common yellow soap, coming down to breakfast with his head still dripping. I don't know if that were the reason; but at any rate he had a most magnificent crop of hair. So these two picturesque persons re-cemented their ancient friendship under the shadow of a social revolution that I am sure my grandfather did not in the least understand, and that William Morris probably understood still less. I suppose that Madox Brown

really expected the social revolution to make an end of all 'damned Academicians.' Morris, on the other hand, probably expected that the whole world would go dressed in curtain-serge, supplied in sage-green and neutral tints by a 'Firm' of Morris & Company that should constitute the whole state. Afterward we all went in to tea in Kelmscott House itself—Morris, my grandfather and several disciples. The room was large and, as I remember it, white. A huge carpet ran up one of its walls so as to form a sort of dais; beneath this sat Mrs Morris, the most beautiful woman of her day. At the head of the table sat Morris, at his right hand my grandfather, who resembled an animated king of hearts. The rest of the long table was crowded in a medieval sort of way by young disciples with low collars and red ties, or by maidens in the inevitable curtain-serge, and mostly with a necklace of bright amber. The amount of chattering that went on was considerable. Morris, I suppose, was tired with his lecturing and answering of questions, for at a given period he drew from his pocket an enormous bandana handkerchief in scarlet and green. This he proceeded to spread over his face, and leaning back in his chair he seemed to compose himself to sleep after the manner of elderly gentlemen taking their naps. One of the young maidens began asking my grandfather some rather inane questions—what did Mr Brown think of the weather, or what was Mr Brown's favourite picture at the Academy? For all the disciples of Mr Morris were not equally advanced in thought.

Suddenly Morris tore the handkerchief from before his face and roared out:

'Don't be such an intolerable fool, Polly!' Nobody seemed to mind this very much—nor, indeed, was the reproved disciple seriously abashed, for almost immediately afterward she asked:

'Mr Brown, do you think that Sir Frederick Leighton is a greater painter than Mr Frank Dicksee?'

Morris, however, had retired once more behind his handkerchief, and I presume he had given up in despair

the attempt to hint to his disciple that Mr Brown did not like Royal Academicians. I do not remember how my grandfather got out of this invidious comparison, but I do remember that when, shortly afterward, the young lady said to him:

'You paint a little too, don't you, Mr Brown?'

He answered:

'Only with my left hand.'

This somewhat mystified the young lady, but it was perfectly true, for shortly before then Madox Brown had had a stroke of paralysis which rendered his right hand almost entirely useless. He was then engaged in painting with his left the enormous picture of 'Wycliffe on His Trial,' which was to have been presented by subscribing admirers to the National Gallery.

This was the last time that Madox Brown and Morris met. And they certainly parted with every cordiality. Madox Brown had indeed quite enjoyed himself. I had been rather afraid that he would have been offended by Morris's retirement behind the pocket-handkerchief. But when we were on the road home Madox Brown said:

'Well, that was just like old Topsy. In the Red Lion Square days he was always taking naps while we jawed. That was how Arthur Hughes was able to tie Topsy's hair into knots. And the way he talked to that gal—why, my dear chap—it was just the way he called the Bishop of Lincoln a bloody bishop! No, Morris isn't changed much.'

It was a few days after this, in the evening, that Madox Brown, painting at his huge picture, pointed to the top of the frame that already surrounded the canvas. Upon the top was inscribed 'Ford Madox Brown,' and on the bottom, 'Wycliffe on His Trial Before John of Gaunt. Presented to the National Gallery by a Committee of Admirers of the Artist.' In this way the 'X' of Madox Brown came exactly over the centre of the picture. It was Madox Brown's practice to begin a painting by putting in the eyes of the central figure. This, he considered, gave him the requisite strength of tone that would be applied to the whole

canvas. And indeed I believe that, once he had painted in those eyes, he never in any picture altered them, however much he might alter the picture itself. He used them as it were to work up to. Having painted in these eyes, he would begin at the top left-hand corner of the canvas, and would go on painting downward in a nearly straight line until the picture was finished. He would, of course, have made a great number of studies before commencing the picture itself. Usually there was an exceedingly minute and conscientious pencil-drawing, then a large charcoal cartoon, and after that, for the sake of the colour scheme, a version in water colour, in pastels, and generally one in oil. In the case of the Manchester frescoes, almost every one was preceded by a small version painted in oils upon a panel, and this was the case with the large Wycliffe.

On this, the last evening of his life, Madox Brown pointed with his brush to the 'X' of his name. Below it, on the left-hand side, the picture was completely filled in; on the right it was completely blank—a waste of slightly yellow canvas that gleamed in the dusk studio. He said:

'You see I have got to that 'X.' I am glad of it, for half the picture is done and it feels as if I were going home.'

Those, I think, were his last words. He laid his brushes upon his painting-cabinet, scraped his palette of all mixed paints, laid his palette upon his brushes and his spectacles upon his palette. He took off the biretta that he always wore when he was painting—he must have worn such a biretta for upward of half a century—ever since he had been a French student. And so, having arrived at his end-of-the-day routine, which he had followed for innumerable years, he went upstairs to bed. He probably read a little of the *Mystères de Paris*, and died in his sleep, the picture with its inscriptions remaining downstairs, a little ironic, a little pathetic, and unfinished.

## 'A NEW AND NOBLE SCHOOL': RUSKIN AND THE PRE-RAPHAELITES

edited by Stephen Wildman, introduced by Robert Hewison

First compilation of all of Ruskin's published writings relating to the Pre-Raphaelites, spanning his career from *Modern Painters* in 1843 (claimed by Hunt to have been an inspiration) to his last Slade Lectures forty years later. Edited from the originals by Stephen Wildman, Director of the Ruskin Library, and introduced by Robert Hewison, a successor to Ruskin's professorial chair at Oxford    978 1 84368 086 4    £19.99

---

## MILLAIS'S COLLECTED ILLUSTRATIONS

Reprinted for the first time since 1865, this anthology, chosen by Millais himself, brings together eighty of his finest illustrations. Collected from his work for Trollope, Tennyson, Collins, and the weekly periodicals over most of his long working life, these prints range from visionary romance to comedy of manners. Together they represent some of the finest black and white work of the Victorian era.    978 1 84368 035 2    £12.99

---

## MILLAIS: A SKETCH
by Marion Harry Spielmann,
with by the artist's THOUGHTS ON OUR ART OF TODAY

First republication since 1889 of the earliest biography and appraisal of one of England's most talented painters. Written by a leading critic and friend of Millais, it gives a fascinating and intimate picture of the Victorian art world. Preceded by Millais' only published writings on art, the *Thoughts on our art of today*, and introduced by Jason Rosenfeld. 33 pages of colour illustrations cover the span of Millais' career   978 1 84368 034 5   £7.99

# THE WORLDS OF JOHN RUSKIN
by Kevin Jackson

*Brilliantly introduces Ruskin to the general reader and offers insights into his continuing relevance    Heather Birchall Art Quarterly*

*A masterly compression of an extraordinary life, offering at every juncture some apt historical context... Among the 165 full-colour images are many outstanding and little-known masterpieces  Stephen Wildman Art Newspaper*

Art critic, architectural visionary, social reformer, climate warner and incomparable teacher:  Ruskin's influential and exhilarating words not only transformed Victorian England but speak to us with increasing urgency today.

This is the first general introduction to Ruskin for many years, and the first to place him in the social, economic and æsthetic world of Victorian Britain. It is also the first to be fully illustrated, with pictures ranging from private notes, and lecture diagrams to presentation drawings – including some of the most beautiful images of the nineteenth century and many never before published. 165 colour illustrations        978 1 84368 044 4    £17.99

---

# MARRIAGE OF INCONVENIENCE
by Robert Brownell

Working from the  original sources, many published here in full for the first time, Robert Brownell overturns the many myths about the ill-fated marriage of John Ruskin and Effie Gray. Illustrated      978 1 84368 096 3     £19.99

---

*FORTHCOMING*

# EFFIE IN VENICE
# MILLAIS AND THE RUSKINS
# THE RUSKINS AND THE GRAYS
by Mary Lutyens
# THE RUSKINS IN NORMANDY
by J. G. Links

---

## BY JOHN RUSKIN

## THE NATURE OF GOTHIC

The first ever facsimile of the Kelmscott edition of the book that showed William Morris the path to his life's work. A cultural high point of the 19th century, and a monument of book design. Preface by William Morris, afterwords by Robert Hewison, Tony Pinkney and Robert Brownell  978 1 84368 070 3  £14.99

## THE STONES OF VENICE

The single most influential account of the essence, elements, social history and future ideals of architecture. 'To see clearly is poetry, prophecy, and religion – all in one', Ruskin wrote; and this abridged edition by J. G. Links brings out all the excitement and urgency of the original, its love of Venice and its unmatchedly beautiful prose. Illustrated  978 1 873429 45 7  £14.99

## THE KING OF THE GOLDEN RIVER

Ruskin's only children's book and the first literary fairy tale in English. With the celebrated original illustrations by Richard Doyle. Introduced by Simon Cooke  978 1 84368 030 7  £9.99

## UNTO THIS LAST

Arguably the most influential political essay ever written, this was a defining text of British socialism, and a decisive experience in the lives of Gandhi and Martin Luther King, amongst many others. Today economists are returning to Ruskin's work, and this edition is introduced by Andrew Hill of the FT. Preface by Clive Wilmer  978 1 84368 044 4  £9.99

## THE STORM CLOUD OF THE 19TH CENTURY

An eerily prescient denunciation of capitalism's assault on the atmosphere. Introduced by Peter Brimblecombe, preface by Clive Wilmer  978 1 84368 078 9  £9.99

# RECOLLECTIONS OF OSCAR WILDE
## by Charles Ricketts

Evocative and touching memoirs of Oscar Wilde, by a close friend (and designer of the sets for *Salomé*). Facsimile of the rare original edition of 1932 by the Nonesuch Press, complete with sumptuous cream and gold cover    978 1 84368 071 0    £9.99

# AUBREY BEARDSLEY
## by Robert Ross

The first ever biography of Beardsley, by his close friend and early patron. An unprecedented glimpse into the life of the æsthetic movement, reprinted for the first time in 80 years. With the original illustrations and catalogue by Aymer Vallance, and a new introduction by Matthew Sturgis  978 1 84368 072 7 £9.99

# AUBREY BEARDSLEY:  A BIOGRAPHY
## by Matthew Sturgis

The finest modern biography of the draughtsman and æsthete who revolutionised English art in six short years    978 184368 074 1 £17.99

# PASSIONATE ATTITUDES:
# ENGLISH DECADENCE OF THE 1890'S
## by Matthew Sturgis

The best introduction yet written to the lives and work of the English Decadents – some of the most vibrant artists and poets ever to have worked in this country    978 1 84368 073 4    £17.99